IMAGES
of America

OAKLAND HILLS

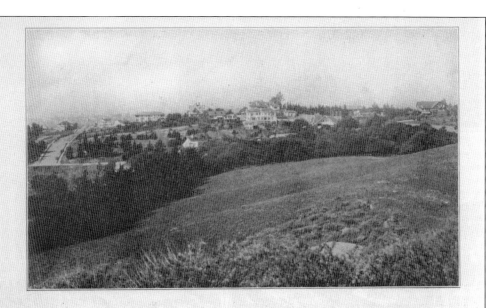

The beautiful hills of OAKLAND

IF ONE would build in fancy a perfect setting for a city it would be difficult to improve upon that which Nature has given Oakland. The broad stretch of level land running down to the Bay for business and industry; the gently rising hills for homes.

As the city grows it is taking advantage of this great natural gift and is reaching to the highest points of the hills with its beautiful homes.

MONTCLAIR, JOAQUIN MILLER ACRES, and other tracts belonging to this company include a vast area of hillside property. At this office, therefore, you can obtain information on any type of upland home that you are interested in.

REALTY SYNDICATE CO.
SYNDICATE BUILDING · OAKLAND

Advertising for homesites in the hills was abundant and flattering. The Realty Syndicate was formed in 1895 by F.M. "Borax" Smith and Frank C. Havens. At the syndicate's peak in 1911, it had developed 13,000 acres of home sites encompassing nearly 100 housing tracts. The Realty Syndicate was responsible in large part for the settling of the hills. (Courtesy Oakland History Room.)

IMAGES
of America

OAKLAND HILLS

Erika Mailman

Published by Arcadia Publishing
Charleston SC, Chicago IL, Portsmouth NH, San Francisco CA

Printed in the United States of America

Library of Congress Catalog Card Number: 2004109845

For all general information contact Arcadia Publishing at:
Telephone 843-853-2070
Fax 843-853-0044
E-mail sales@arcadiapublishing.com
For customer service and orders:
Toll-Free 1-888-313-2665

Visit us on the Internet at www.arcadiapublishing.com

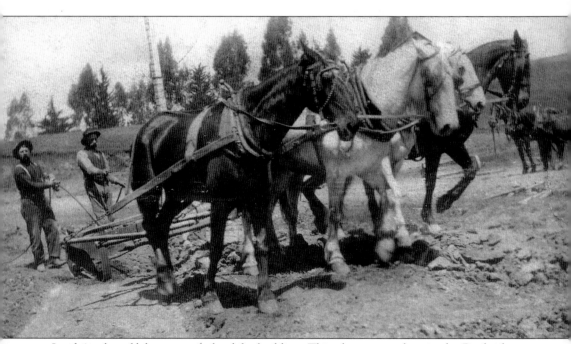

It takes a lot of labor to ready land for building. This photo was taken in the Rockridge area. (Courtesy Oakland History Room.)

CONTENTS

ACKNOWLEDGMENTS

Recently, librarian Steve Lavoie dryly told me that the Oakland History Room should be moved closer to my house since I was there all the time. He and librarian Kathleen DiGiovanni have been of the utmost help in preparing this book (and stretching back for years before this as well). Their knowledge of local history is always a marvel to me; it's no random matter that they have ended up as the caretakers of the incredible materials at the Oakland History Room, which include carefully catalogued images, newspaper clippings, books, maps, and more. Thanks also to Lynn Cutler and the now-retired Bill Sturm, who helped build this collection to what it is today. From the very first day I stepped foot into the Oakland History Room, the staff members have made me feel welcome and have assisted in every way possible.

Kathleen and Steve, you are an inestimable help, and I value your good nature, tenacity, and sometimes outright glee in the arena of local history.

I am of course in large debt to the City of Oakland, under whose jurisdiction the library and history room fall. The use of these images is most gratefully acknowledged.

I also owe a debt of thanks to organizations like the Oakland Cultural Heritage Survey and the Oakland Heritage Alliance, whose collections and publications are of such value. The survey documents are invaluable to get a quick read on a building, and OHA's newsletters contain 20-plus years' worth of historians' well-researched articles. Every bit as important is the friendliness and interest with which the individuals associated with these groups meet a researcher's questions. Betty Marvin, Gail Lombardi, Pamela Magnuson-Peddle, Esther Hill, Naomi Schiff, and many more: I thank you for all the questions you have helped me answer (or shrug a collective no-way-to-know shoulder about) over the years. Oakland is truly lucky to have such an infrastructure in place to help those interested in its history.

Intense gratitude goes out to Alan Howard, who rescued me by helping me scan a large number of these photographs.

Finally, I would like to thank the dozens of individuals who sent photographs, invited me into their homes to look at their albums, or otherwise facilitated my capture of an image or information. I made some wonderful connections with people and am touched by their generosity, as well as their shrewd wisdom in keeping these images in an era where the past seems to get short shrift. They are: Barry Bennett, Robyn Berry, Ruth Bittman, Fred Booker, John Bosko and his wonderful collection, John Brennan, Rosalie Brown, Janet Cornell and Thelma Krogh, Dennis Evanosky, Claudia Falconer, Teresa Ferguson-Scott, Kathy Ferreira, Erich Fink, Joan Flanagan, Kevin Flynn, Brian Foster, Werner Gemmer, Patricia M. Green, Cynthia Haines, Kenneth G. Hecht Jr., Dana Heidrick and Lance Nishihara, Gary Jackson, Nancie J. Glenk Janiak, Jennie Hender and Kathleen Catahno, Inge Junginger, Terry Kulka, Kurt Lavenson, Carol Lewis, Helen Lore, Mary McNeill, Robert Medeiros, The Montclarion, Claudia Yochem Neill, Lestelle Manley Nichols, Mark Nollinger, Audrey O'Brien, John Ochsner, Chris Richard, Betty J. Steele, Howard Stein, Susan Suzuki, Oakland Museum of California, *Oakland Tribune*, Oakland Zoo, Oakmore Homes Association, Jean Owens, Herb and Renee Schmidt, Don Schnars, Betty J. Steele, Frank Uher Jr., Bud and Barbara Veirs, Shirley Warwick, Al Wood, Carolyn Younger, Millie Zaludek, and Stacey Zwald.

INTRODUCTION

The Oakland hills are a place where one can peep through the trees to catch a startling scene of cities nestled around the azure waters of the bay. The hills are urban yet retain a sense of sylvan rusticity. The neighborhood names reflect this tie, with many referring to trees (Laurel, Redwood Heights, Oakmore, Oak Knoll, Piedmont Pines, Sequoyah Heights) or other natural features (Rockridge, Glenview, Leona Heights). Many districts have the suffix "mont" in their names, for mountain.

My biggest regret while assembling this book was that there were no images of the people who first lived in these hills. The Huchiun bands were largely disbanded or had even vanished by the advent of photography. While early etchings exist of flatland peoples, I was unable to locate any depiction of aboriginal hills people.

These Native Americans lived along the various creeks that once roared down the hills. It's interesting to look at a map showing Oakland's creeks, as they were like blood vessels in a body: profuse, branching, confluent, and vital. But today the water often rushes underground through concrete tunnels. Trestle Glen Creek, for example, only flows on the surface on the Piedmont side—and that intermittently—and for a short stretch near Crocker Highlands School. Rather than a healthy blue line on the map, many creeks show a preponderance of red dots, indicating a culverted waterway. Sausal Creek is a wonderful exception.

When the Spanish arrived, the Huchiun greeted them with gifts of dried geese stuffed with grasses and received beads in return. A contemporary account of Huchiuns coming aboard the Spanish ship *San Carlos*, moored near Angel Island, illustrates their democratic hospitality. They distributed pinole cakes and made pains to ensure that each of the ship's crew ate. The reciprocal gift of pilot bread was similarly provisioned among the Huchiuns.

Randall Milliken's excellent book, *A Time of Little Choice: The Disintegration of Tribal Culture in the San Francisco Bay Area 1769–1810*, describes the Huchiun lands as extending "over a large area along the East Bay shore, from Temescal Creek opposite the Golden Gate north at least to the lower San Pablo and Wildcat Creek drainages in the present area of Richmond." He names an astonishing 96 different tribal groups, which casts doubt on the popular catch-all term "Ohlone."

Huchiuns began to be baptized as Catholics in the 1780s (with 165 baptized in the banner year 1794), and misguided "weddings" were performed that discounted pre-existing polygamous bonds. Starvation and disease—running the gamut from tuberculosis and syphilis to measles— plagued the missions, not to mention the Huchiuns' despair over the loss of their culture. Within 40 years of the Spaniards' arrival, the Huchiuns had been assimilated or killed.

For some, the hills retain a haunting echo of these people's gentle use of the land, even while they appreciate the lively neighborhoods that have sprung up in their place.

There's also very little visual record of the Peralta family's reign over the hills. Mexican soldier Luis Maria Peralta, who received most of the East Bay as a sort of retirement gift from the king of Spain, passed his lands to his sons around the 1840s. It was in 1839 that the daguerreotype process reached the general public, so Peralta's family and his ranch were not photographically documented.

Settlement of the hills during the early Gold Rush era is also scantily recorded. A few wonderful images exist, but not until the turn-of-the-century building boom did a flush photographic record appear.

There are, however, plenty of photos of the subdivisions that stretched out upon the hills. They were made possible by the ingenious strategy of running streetcars to building sites; both the properties and the transit depended on each other to flourish.

This book is organized by neighborhood, moving generally eastward across the map. The final chapter is about the 1991 firestorm, an event that revealed both how vulnerable the hills are—and how resilient.

One

MONTCLAIR
AND ENVIRONS

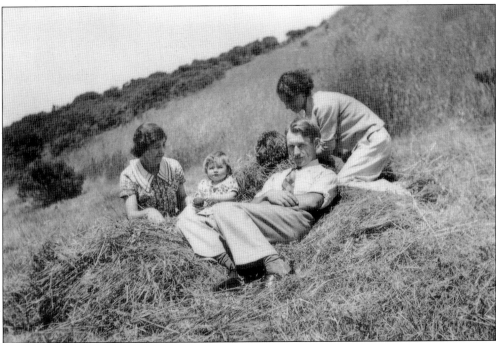

Montclair was once filled with many grassy hillsides, perfect for a ramble. Here the Fredson family relaxes on vacant lots next to their Colton Boulevard home in 1938. The family, from left to right, included Zella Fredson, her granddaughter Janet Krogh, the family dog, her son-in-law M.P. Krogh, and daughter Thelma Krogh. Thelma says, "The only people who used to come up here were friends or people who were lost. Now it's a freeway." (Courtesy Thelma Krogh.)

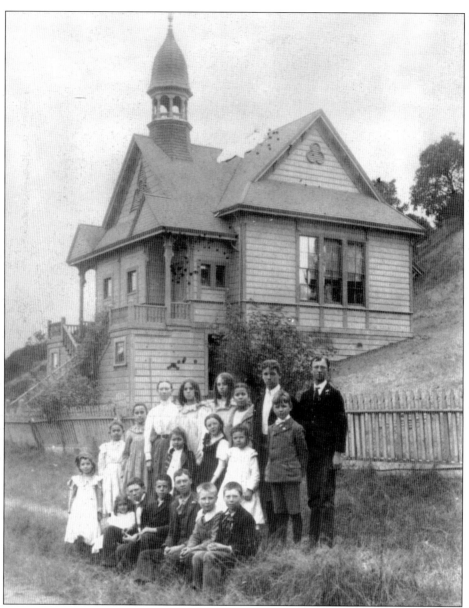

Students gather before the Hays School, located where today's Moraga Avenue firehouse stands. The school was named for John C. Hays, the famous Texas Ranger who served as San Francisco sheriff during the rough years of vigilantism. He settled in the Oakland hills, and three years after his 1883 death, residents erected the school and named it to honor him. At the time, Montclair was rife with orchards, farms, and dairies. Children of the laborers in these industries, including a number of Portuguese-American families, attended the Hays School. One of the early teachers, Miss Esther E. Irwin, lived at Fourteenth and West Streets, and came to school each day astride a horse, making a leisurely trip of one and a half hours each way. It is important to note she was a "miss," as women were prohibited from teaching if they were married or contemplating it. In 1913, railroad track was laid along the edge of what soon became Montclair's commercial center, and the remote area began bustling with real estate deals. The school closed that year. (Courtesy Oakland History Room.)

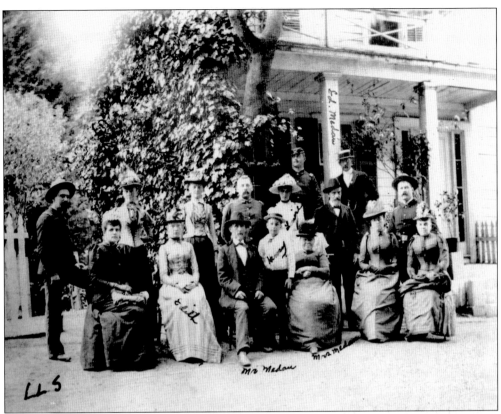

Medau Place in Montclair Village was named after the Medau family, pictured here outside their home, which once sat 40 feet from the pond in today's Montclair Park. That pond had an island in the middle, and the Medau children would walk to it across a wooden plank from the shore. One year the pond froze, and they had a delightful time sliding around on the ice. German-born tobacconist John H. Medau came to the United States in 1851, and in 1857 bought 487 acres sprawling across what is today the entire village of Montclair. He met another German immigrant; they married in June 1860 and had at least eight children. At first, Medau grew fruit and raised stock but later decided it was more lucrative to switch to grain and hay. At one point he ran an extensive dairy with 100 cows. In 1901 he sold the ranch to a real estate syndicate for $130,000. (Courtesy Oakland History Room.)

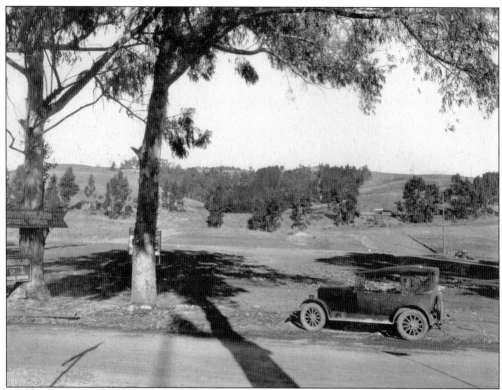

Montclair was a lonesome place when realty signs (visible at left) first went up. The driver of the car in the top photo has clearly abandoned it to document the birth of this district. In the bottom photo, horseback riders check out the sales huts. The Realty Syndicate was F.M. "Borax" Smith's company, formed with Frank C. Havens in 1895. Smith, who had made his fortune mining borax, bought up the various privately owned transit lines in Oakland and organized them into the Key System. He ran lines to newly developing properties, a symbiotic relationship as the properties and transit depended on each other. Havens withdrew from the syndicate in 1910. Three years later Smith, who at one point was worth $30 million, had bad luck with lenders and hit rock bottom. Luckily, this plucky entrepreneur reinvested in borax, but the Realty Syndicate was by then out of the picture. (Courtesy Oakland History Room.)

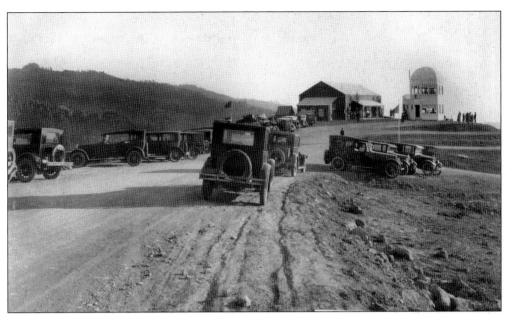

Developers created amusements to attract potential buyers. The observatory in the top photo draws people who can be seen crowded into the second-floor observation rotunda. In the bottom photo, a long view shows how remote the location is at that time. (Courtesy Oakland History Room.)

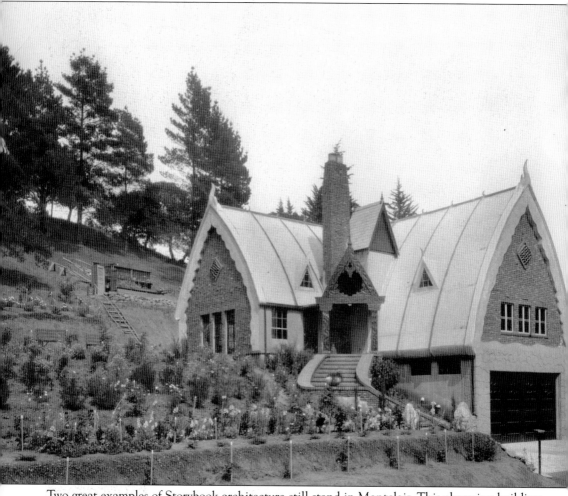

Two great examples of Storybook architecture still stand in Montclair. This charming building is not Hansel and Gretel's cottage but the firehouse, built in 1927 on the site of the old Hays School. The roofing, though today painted white—perhaps to resemble snow—is made of copper and meant to represent flames. Some of the windows also have curved panes, perhaps meant to suggest glass melting in the heat of a fire, or perhaps that is a Storybook trademark. Its construction is almost entirely of pre-cast concrete. Windows, door frames, pipes, plumbing, electrical conduits, and even door hinges were cast in the cement when it was poured or molded. The Moraga Avenue firemen built and tended terraced gardens and created greenhouses (one made of glass from illegal pinball machines confiscated by the city!), a fish pond, and an aviary. The former site of Engine Company 24 may get a second life; residents hope to see a firefighting museum housed there. (Courtesy Oakland History Room.)

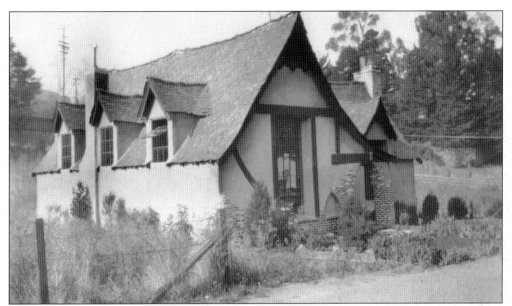

Equally sweet is the Montclair library, which also features the pitched roofs and gables of Storybook style. The railroad trestle can be seen in the background. A children's wing was added to the library in 1963 and an addition to that in 1999. (Courtesy Oakland History Room.)

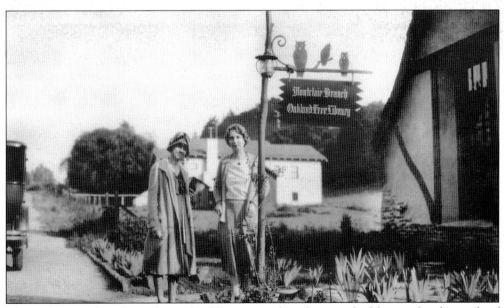

The twilight owls still perch on the library sign, but the now highly populated stretch of Mountain Boulevard looks quite different. The sign was made for $30 by Berkeley Metal Arts, which also constructed the weathervane. (Courtesy Oakland History Room.)

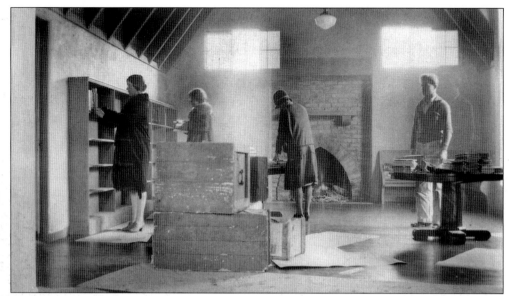

This is how a library begins—with a handful of books placed on shelves. One librarian wrote in her March 1930 report, "This community is friendliness personified. It is like a little town by itself." This photograph was taken February 1930. (Courtesy Oakland History Room.)

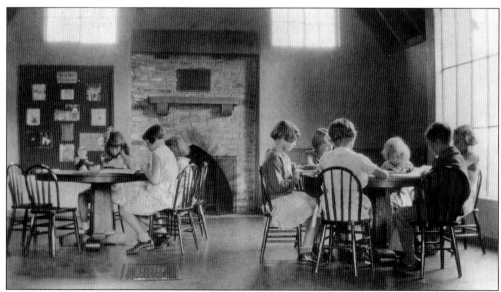

A year later, in November 1931, children are shown ensconced in the library, reading earnestly. A plaque above the fireplace, still there today, thanks Chauncey Gibson for donating funds to build the library. Children wrote letters thanking Gibson one month after the library opened; the kindly benefactor died shortly thereafter. He was 90 and a child-welfare advocate whose only son died as a child. (Courtesy Oakland History Room.)

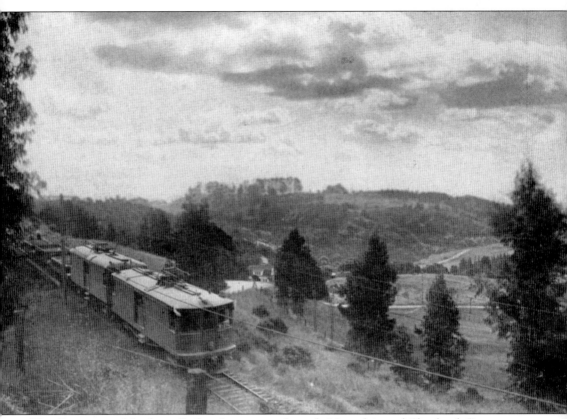

The Sacramento Northern Railroad once ran through Montclair and Shepherd Canyon on its way to Sacramento. The canyon (and a now-culverted creek) is named for farmer William Joseph Shepherd, who arrived from England in 1869. The trains carried passengers and freight through the densely-wooded hills and through Sequoia station, which sat right in the heart of Shepherd Canyon. Another station was at Moraga and Thornhill. The railroad began in 1909 as the Oakland & Antioch Railway. Two years later the Sacramento Northern Railroad leased the O&A right-of-way through the canyon. For a while business boomed, but then the Great Depression hit. Even the 1937 construction of the Bay Bridge (which then carried trains on its lower deck) couldn't help increase passenger traffic, so the railroad mostly focused on freight. The railroad had another heyday during World War II when it transported materials, but in the early 1950s things were on the decline again, and the final train ran February 28, 1957. Soon after, the tracks were dismantled and a tunnel at Gunn Drive was sealed off. (Courtesy Oakland History Room.)

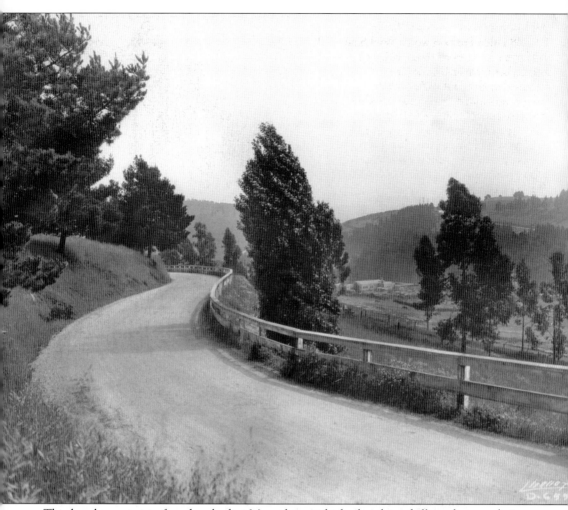

This handsome twist of road embodies Montclair, with the low-lying hills and pastoral vistas. But apparently some wished to see it embody Piedmont rather than Oakland, because in 1950 residents of Montclair, Piedmont Pines, and Montera moved to secede from Oakland and join Piedmont instead. The secessionists were upset with the development of roads, transportation, zoning, education, and police service. The publisher of the *Montclarion*, Fred Graeser, was chairman of the secessionists' PR committee, and said, "They're making us pay city-sized taxes—but we're getting only country cousin service." Fortunately the secessionists were unable to gather the required signatures on their petition of one-quarter of the affected residents. The change of alliance wouldn't have solved their problems anyway: any bond debts carried by their neighborhood would continue to be paid by them, even if they became Piedmonters. (Courtesy Oakland History Room.)

This story starts with a raffle. In 1928 Hilda Fredson won a Wickham Havens lot in Forestland and gave it to her brother Charles, who traded up for a lot with a better view on Colton Boulevard. He then showed sweetheart Zella Patterson the partially built home and asked if she would like to live there. It was certainly an unusual marriage proposal! Shown here in March 1930 are, from left to right, Hilda, her father Israel, Zella, and Hilda's boyfriend. (Courtesy Thelma Krogh.)

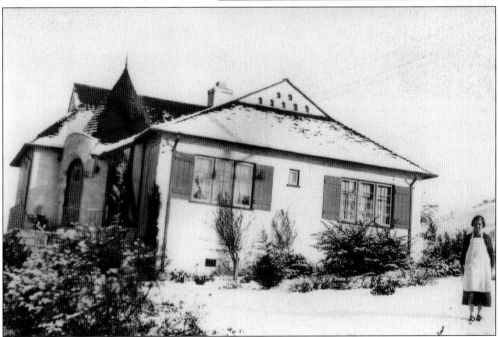

It's not often the snow flies in Montclair, and even rarer for it to stick. Zella Fredson's mother, Emma Berry, stands in the yard without her coat in this February 1932 photograph, her face attesting to the chill in the air. (Courtesy Thelma Krogh.)

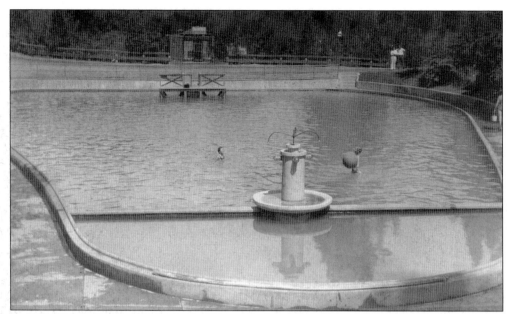

The Wickham Havens subdivision of Forest Park was located in Shepherd Canyon. A 1924 advertisement enthused, "Trees! Sunshine! The invigorating air of the hills! Ferns! Flowers! It even has a forest pool for property owners and their friends to swim in." The forest was planted by Frank C. Havens in 1904. The pool was originally a watering hole for cattle, then became a muddy swimming hole, and then was cemented into a $10,000 pool (nearby home sites were $475). Its close proximity to Thornhill Road prompted concerns in the mid-1940s about traffic during swim season. Today the fountain in the middle no longer exists, but the pool does, as the Montclair Swim Club on Woodhaven Way. (Courtesy Oakland History Room.)

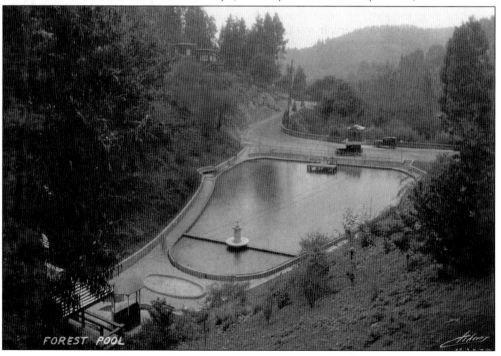

FOREST POOL

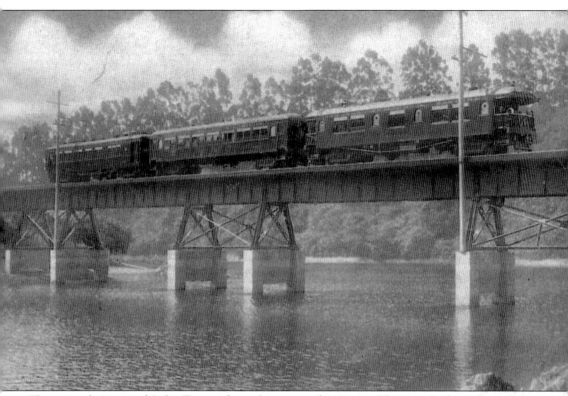

The train that crossed Lake Temescal was known as the *Comet*. This postcard extolling the virtues of the fast electric train was mailed in May 1915 for 1¢. The lake was created by damming Temescal Creek in 1868. Tons of dirt were washed from a 160-foot-deep canyon to create the dam, and herds of wild mustangs were run at the site so their hooves would compact the earth. The resulting reservoir was a source of water piped to homes by the Contra Costa Water Company. In 1938, however, it was opened as a swimming/recreation area. In the late 1970s, silt buildup from nearby freeway and Caldecott Tunnel construction threatened the lake. Previously it had been 80 feet deep; by then it was a mere 18 feet deep. Algae buildup meant one couldn't see farther than six or eight inches into the water. The *Tribune* reported, "If this process continues much longer, Temescal will become a fetid quagmire, and the smell of rotten eggs (hydrogen sulfide) will drift over nearby neighborhoods." State, EBRPD, and federal monies bailed out the lake. Today, the lake is again safe for swimming. (Courtesy Oakland History Room.)

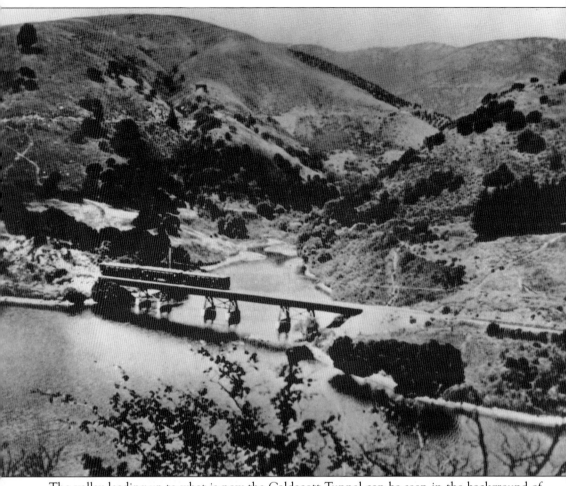

The valley leading up to what is now the Caldecott Tunnel can be seen in the background of this *c.* 1930 photograph. The road is Old Tunnel Road. Lake Temescal was once the site of a bloody battle: the fight to provide water to Oakland's residents. Anthony Chabot's Contra Costa Water Company went head-to-head with William Dingee's Oakland Water Company. Dingee's residential cesspool drained into Chabot's water supply, and Dingee alerted the papers that his competitor's water was bacteria-laden. In turn, Chabot accused Dingee's water of being full of alkali. An 1876 newspaper reported, "The water furnished the inhabitants of this city has carried more people to the grave . . . than all the rotgut that has been sold and consumed in this state. . . . The water has been so filthy that a respectable cow would turn from it in disgust." Dingee tunneled into the Montclair hills to obtain water and, for a while, millions of gallons daily poured through the now closed tunnels. Eventually, the feuding water companies merged. (Courtesy Fred Booker.)

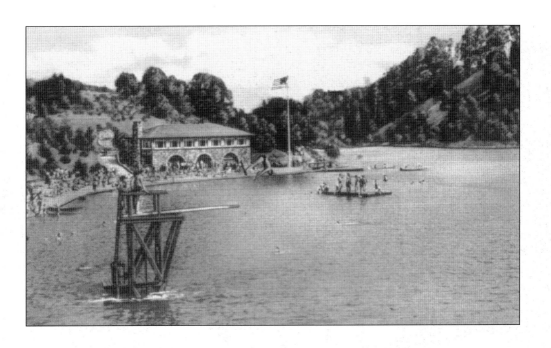

These postcards show Lake Temescal's popularity with bathers when the reservoir no longer provided drinking water. (Courtesy Oakland History Room.)

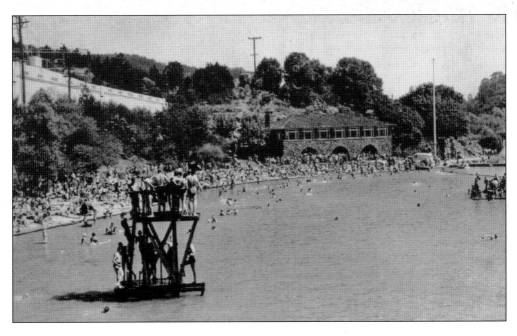

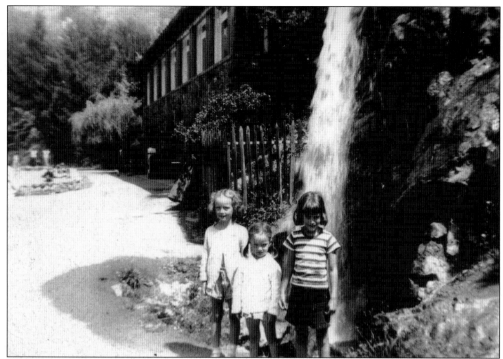

In front of the historic boathouse, three girls enjoy the waterfall on a sunny day in 1949. They are, from left to right, Molly Green, Pat Green, and a family friend. The boathouse was built by the WPA in 1938 and is an example of the National Park Service's rustic style. The boathouse was closed in 1992 for seismic repairs. A year-long $1 million restoration project was completed in 2003. (Courtesy Patricia M. Green.)

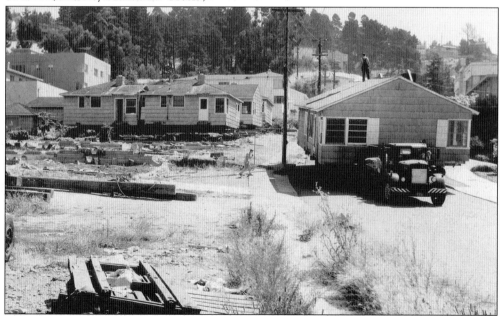

This photograph shows the Safeway construction site on Mountain Boulevard in the early to mid 1960s, with homes being moved to make way. (Courtesy Oakland History Room.)

This 1950s view of Montclair shows that Route 13 is not quite a route yet. At the corner of LaSalle and Moraga, a gas station sits where today locals eat sushi. Crogan's restaurant is Jeffery's, a men's clothing store. Back in the 1920s, LaSalle was called Hampton Road. (Courtesy Oakland History Room.)

This c. 1930 photograph also shows LaSalle, in an even less recognizable guise, looking west from the top of LaSalle, where the parking garage stands today. The building at left is a Realty Syndicate bus garage (today Le BonBon). The middle building is Montclair Pharmacy (now Crogan's), and the little building on the right is the oldest building still standing in the village (now a stationers). (Courtesy Oakland History Room.)

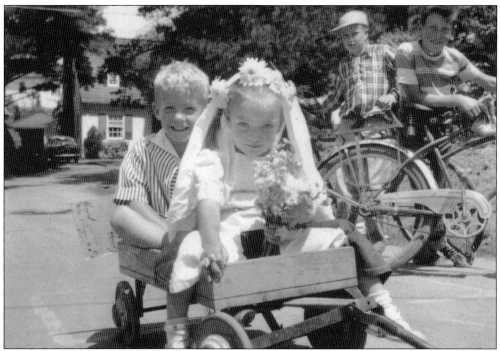

It's a match made in heaven—or at least in a wagon. Jackie Singer (left) is the groom in this make-believe wedding, with Pat Green as his determined-looking bride, and Robert Gretzner and Butch Hickish trying to come up with reasons why to speak now or forever hold their peace. This 1949 ceremony took place on Oval Road, looking toward Pinewood Road. (Courtesy Patricia M. Green.)

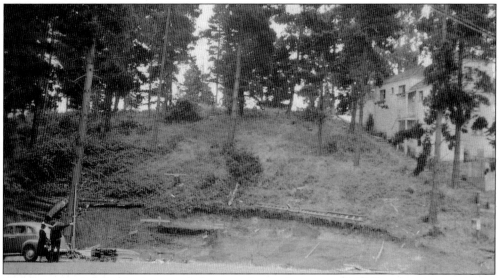

Piedmont Pines is certainly named for something: the pines. Tucked into the area where Mountain Boulevard and Park Boulevard met before the construction of Route 13, this Mitchell & Austin subdivision had lots for sale in 1934. In this fall 1941 photograph, owner Mr. Cloer points out features of the lot to his wife. The home they subsequently built at 6316 Ascot Drive still stands; the present owner purchased it from Mr. Cloer. (Courtesy Susan Suzuki.)

Two

ROCKRIDGE
AND CLAREMONT

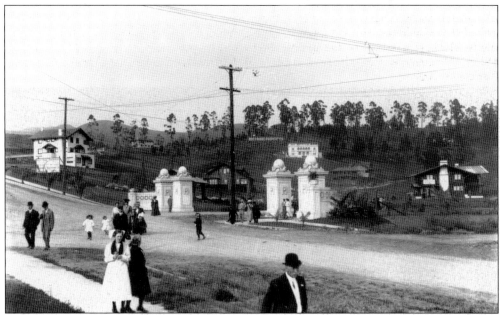

The white gates topped with spheres are a well-known landmark welcoming people to the Rockridge neighborhood. Here, *c.* 1910, families investigate "Rock Ridge Properties," which, according to the sign on the left, are selling for $15–$30 per foot of street frontage. Rockridge was first developed in 1909, 30 years after owners Col. Jack Hays and Horatio Livermore filed a subdivision in 1879. The Livermores planted eucalyptus, pine, and cedar on the property and around 1900 began selling off the land. The first portion of the estate went to the Claremont Country Club, another to banker Philip E. Bowles, and the third part to Rock Ridge Properties to develop. (Courtesy Oakland History Room.)

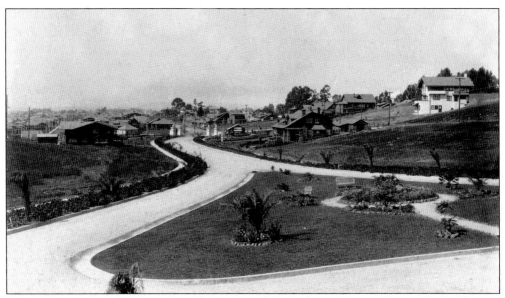

Shown here is the view from the other side of those famous gates, with a nicely-landscaped island. Walter Reed, brother of tract salesman Fred Reed, created the stone pillars that mark the entrance to Rockridge. (Courtesy Oakland History Room.)

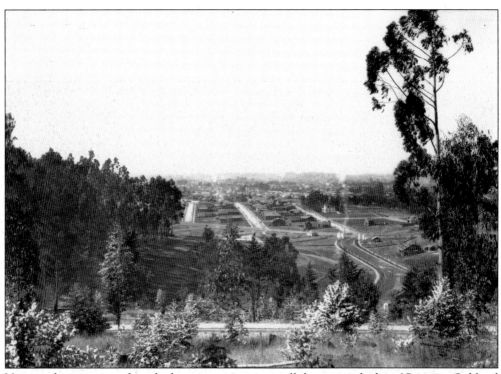

Viewing the same gates from farther away, one can see all the way to the bay. (Courtesy Oakland History Room.)

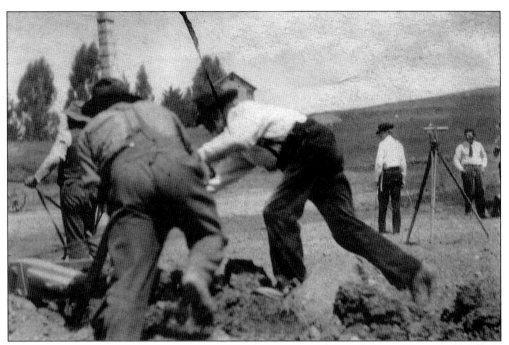

Grading the land was hard work for the men . . . (Courtesy Oakland History Room.)

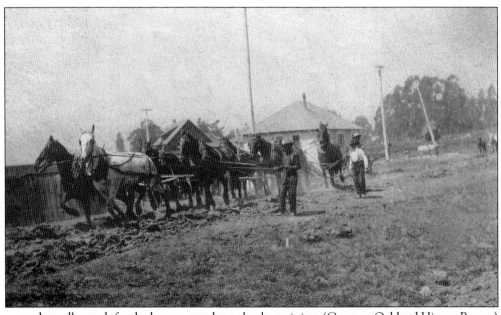

. . . and equally tough for the horses, seen here clearly straining. (Courtesy Oakland History Room.)

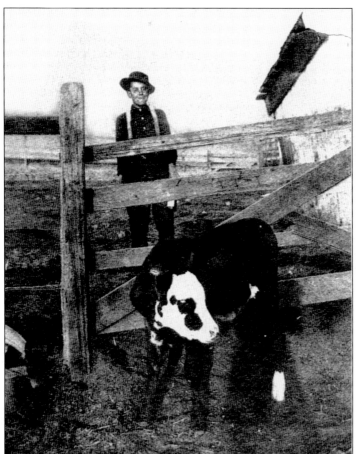

William Casaurang beams at a calf on his family farm, the Oakland Stockyards, on upper Fifty-ninth Street (today's Chabot Road). Casaurang used to deliver milk to author Jack London and also remembered the 1906 earthquake. He was 15 at the time and said the earth's motion made him and the cattle fall to the ground. From the farm he could see the smoke as San Francisco burned. (Courtesy Joan Casaurang Flanagan.)

This photograph shows the Casaurang farm in the 1880s. The farm was started by William's father, Frank Casaurang. (Courtesy Joan Casaurang Flanagan.)

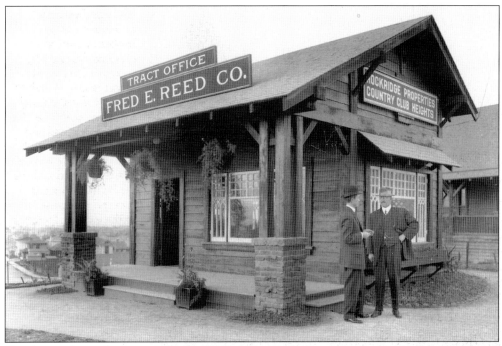

Gentlemen discuss business at the Fred E. Reed tract office, *c.* 1910. Reed, who was subdivision manager for Laymance Real Estate Company, reported, "We determined to build Rockridge to an ideal. Not a near-ideal—but absolutely as near as we could conceive it." Laymance provided transportation to potential buyers as far away as Sacramento. Reed's efforts paid off: on the first day of sales, he sold $186,000 worth of lots. (Courtesy Oakland History Room.)

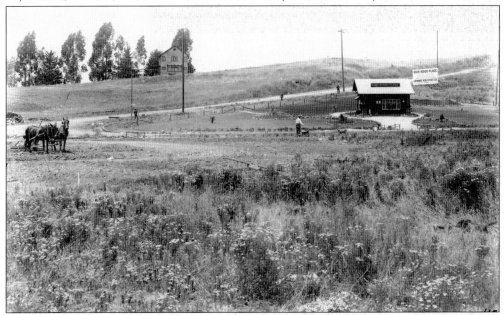

In this photo, the white Rockridge gates haven't even been built yet. In the midst of the black-eyed Susans, men and horses lay the groundwork for a new neighborhood. (Courtesy Oakland History Room.)

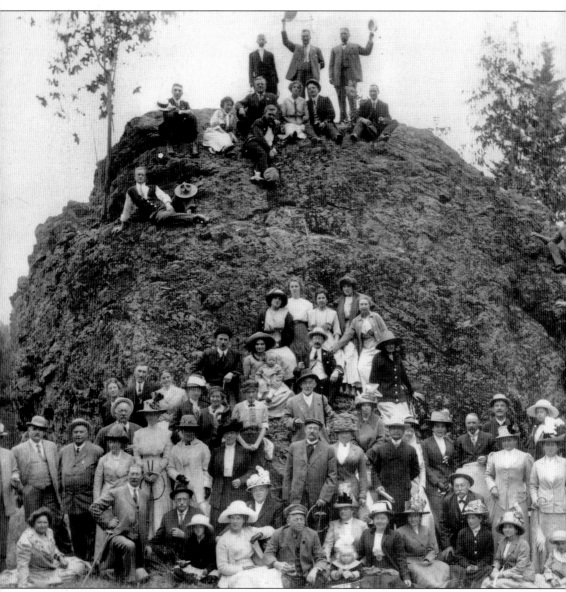

This photo shows what puts the "rock" into Rockridge. At the top, gentlemen raise their hats in celebration of their successful summiting. A document in the Oakland History Room seems to suggest that this was the 27th annual picnic of the Deutscher Club of Oakland, assembling "about three score of the wealthiest German residents in Alameda County." The company tackled the enormous rock "in the name of the German emperor, the President of the United States, the Ladies, the officers and members of the Deutscher Club and other toastable characters, official and unofficial." The members arrived in a Laymance Real Estate Company touring car and jokingly contemplated creating a team to play an Alpen game called Schinkenklopfen at the Olympic Games in Sweden. The rock is located at the corner of Glenbrook and Bowling Drive in Claremont Pines. Due to grading, it's no longer such an impressive boulder and is nearly hidden by vegetation. (Courtesy Oakland History Room.)

This Laymance Real Estate Company postcard view is of Cactus Rock, possibly the rock in the previous photo. The postcard can be dated between 1907 and 1914, when Glenbrook and Bowling Drive did not exist. Acacia Drive was the nearest road at the time. (Courtesy Oakland History Room.)

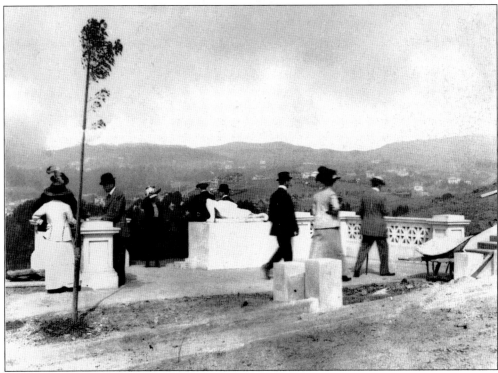

In this photograph, women and men in their finery step around abandoned lumber and a wheelbarrow. Clearly, building is afoot here in the hills. (Courtesy Oakland History Room.)

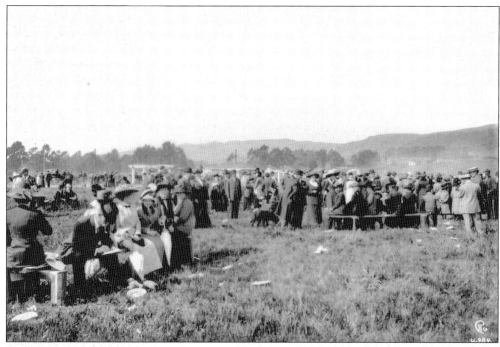

In this photograph, masses of people congregate, surrounded by lots of litter—perhaps discarded real estate pamphlets? A pergola brings elegance to the otherwise natural meadow. (Courtesy Oakland History Room.)

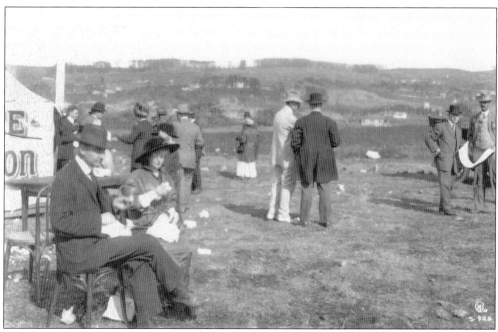

At left, a couple satisfies their appetite, while at right men hold blueprints. This rural stretch will soon be filled with houses. (Courtesy Oakland History Room.)

This vintage postcard shows some Rockridge houses, including that of banker Philip E. Bowles, a significant landowner with 58 acres between Acacia and the Claremont Country Club. The message space on the back was suggestively preprinted, reading: "I finally bought a lot myself. What do you think of that? Me! Simply couldn't help myself. Look it up on your map, Lot 8, Block 1. Right by the car line. O.R.N." (Courtesy Oakland History Room.)

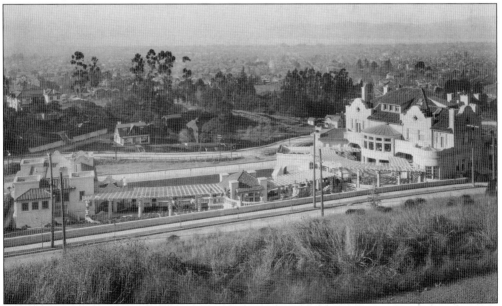

Some of the homes in the area were unquestionably palatial. Here's an estate in Claremont that definitely made good use of its space. (Courtesy Oakland History Room.)

35

Wickham Havens was a hills developer, akin to the Realty Syndicate. This photograph of 6197 Contra Costa Road comes from an album of Wickham Havens' "new" homes. (Courtesy Oakland History Room.)

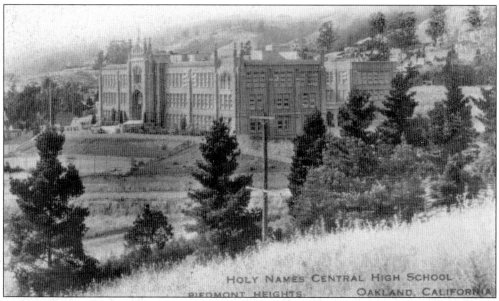

HOLY NAMES CENTRAL HIGH SCHOOL
PIEDMONT HEIGHTS OAKLAND, CALIFORNIA

Holy Names High School on Harbord Drive opened in August 1931, combining four high schools administered by the sisters of Holy Names. Originally, the school began in 1868 at Lake Merritt as the Convent of our Lady of the Sacred Heart. In time it outgrew its home and moved to the nearly six acres on Harbord Drive, while the related Holy Names College was built in Redwood Heights. (Courtesy Oakland History Room.)

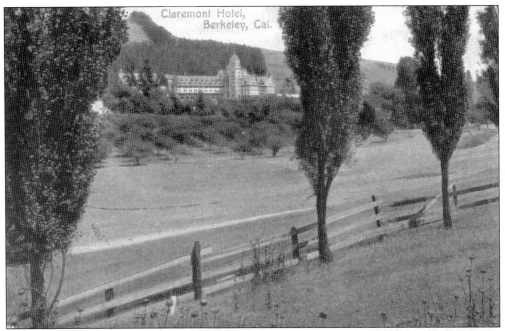

The crowning glory of Claremont is without a doubt the Claremont Resort and Spa, once known as the Claremont Hotel. This postcard was mailed in November 1908 (for 1¢) to an address on Magnolia Street in Oakland. It was written completely in German, attesting to the influx of German immigrants to the area. (Courtesy Oakland History Room.)

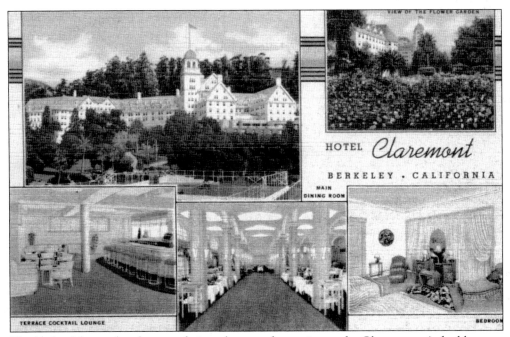

The back of this undated postcard gives the rates for staying at the Claremont: A double room with a private bath cost between $3.50 and $8, while a room without a bath was $1.50–$2. (Courtesy Oakland History Room.)

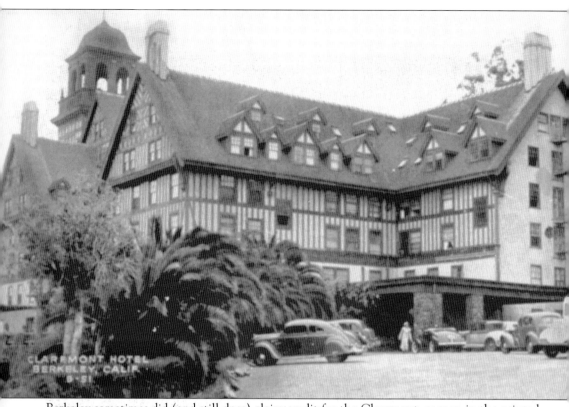

Berkeley sometimes did (and still does) claim credit for the Claremont, as seen in the printed text on this image. The photograph shows that the Claremont, when originally built, had a dark, half-timbered, northern European look. It was designed by architect Charles Dickey, who was also responsible for the beautiful Rotunda Building in downtown Oakland. Frank C. Havens began building it in 1906 while still a Realty Syndicate partner with Borax Smith, but a financial panic stopped construction. After a few fits and starts, and his withdrawal from the syndicate, Havens joined forces with a man who had found gold in the Klondike, and the building was finally finished in 1915. Visitors to the 1915 Panama-Pacific International Exposition were able to stay in the recently completed hotel. Count Basie, Louis Armstrong, and Tommy Dorsey all played at the Claremont. During the 1991 firestorm, the Claremont nearly went up in flames, but firefighters made herculean efforts to save the landmark. (Courtesy Oakland History Room.)

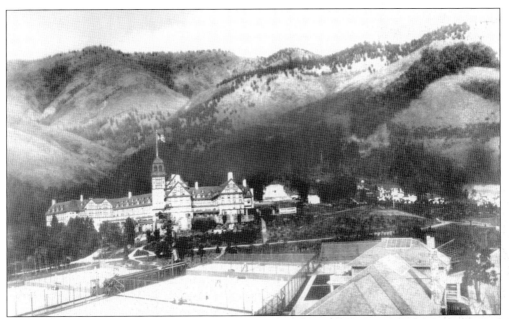

This photo, taken in the 1920s or 1930s, reveals a glimpse of the streetcar between the tennis courts that once ran up to the hotel's front door. (Courtesy Oakland History Room.)

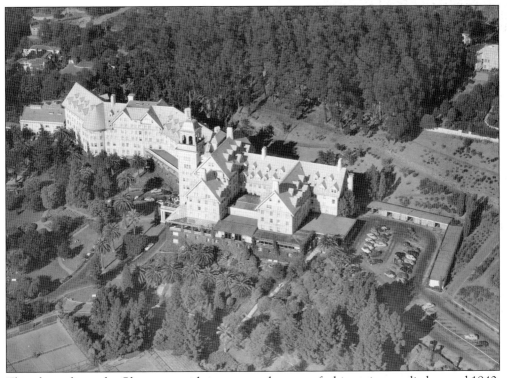

This photo shows the Claremont with its present-day coat of white paint, applied around 1940. The old-fashioned sedans in the parking lot, however, reveal that this is not a modern picture. (Courtesy Oakland History Room.)

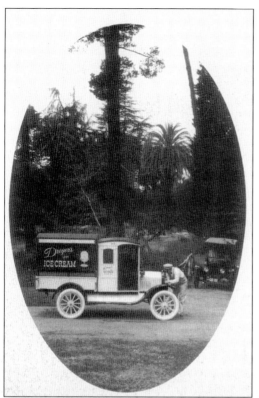

Dreyer's has been around since 1928, making sure Rockridge can indulge its sweet tooth. Here, the driver has to crank the engine to get the ice cream truck started. The first Dreyer's factory was on Grand Avenue. In 1929, the company invented Rocky Road ice cream. German-born William Dreyer used his wife's sewing scissors to cut the marshmallows down to size. Courtesy Oakland History Room.)

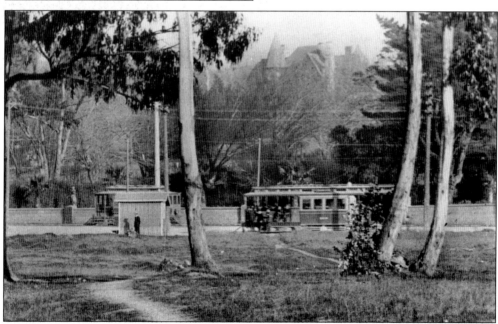

In this c. 1912 photo, the trolley boards passengers at Broadway and College, with the Treadwell mansion looming in the background. In 1922 the four-acre Treadwell estate was purchased by an art school that in 1936 was renamed California College of Arts and Crafts. The Treadwell mansion still stands. (Courtesy Oakland History Room.)

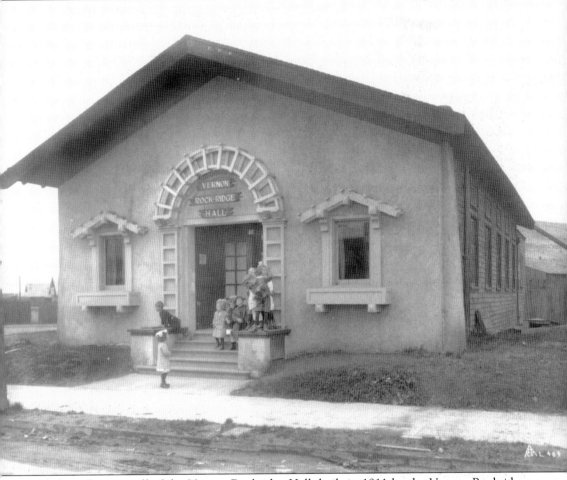

Kids love the stairwell of the Vernon Rockridge Hall, built in 1911 by the Vernon-Rockridge Improvement Club, one of the earliest neighborhood improvement associations in Oakland. The club was formed by residents of Rockridge and the nearby Vernon District (between College and Broadway). This club cleaned streets, weeded, and worked to get a fire station and improved transit service. Unlike the original Craftsman façade, the structure now has a faux Olde English façade and a blinking martini sign, the clubhouse at 5515 College Avenue is now the Publik House, a tavern. At various times the building was called "The Hut" or "The Club." (Courtesy Oakland History Room.)

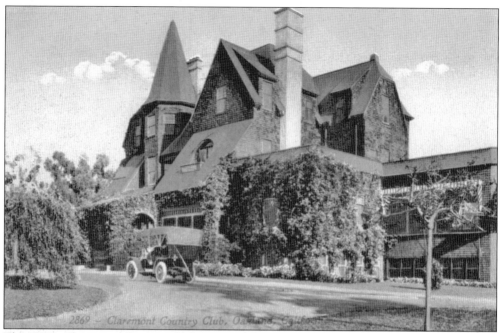

This 1913 Claremont Country Club postcard has a quaint message on its back. The writer arranges with a friend to meet for tea at the Emporium downtown, and declines an invitation to stay overnight in Belmont. The club's original clubhouse, the Shingle-style Horatio Livermore mansion shown here, burned to the ground in 1927, killing the caretaker. A new clubhouse was erected in 1929. The club started in 1903. (Courtesy Oakland History Room.)

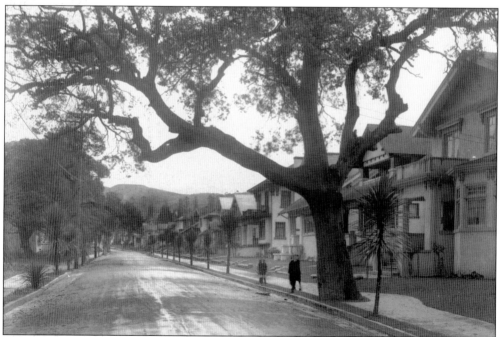

Keith Avenue is fairly representative of a Rockridge neighborhood. It was the site of the first farmhouses in the 1870s and 1880s. (Courtesy Oakland History Room.)

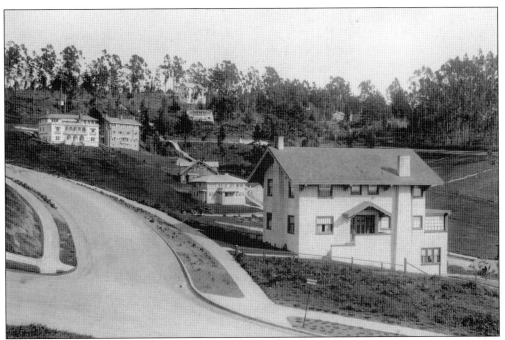

In this photo, a dog guards the corner of Ocean View and Broadway. (Courtesy Oakland History Room.)

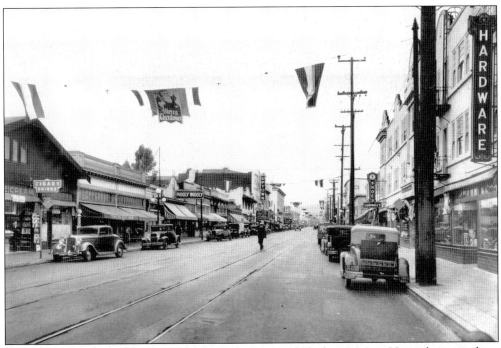

This was College Avenue in 1930, looking north toward Shafter Avenue. Not only was parking available, it appeared to be free as no meters bedevil this stretch of College. The Uptown Theater is today part of BART's parking lot. The building at far left is the Vernon Rockridge Hall. Streetcar tracks take up a large part of the roadway. (Courtesy Oakland History Room.)

In 1931, Chabot Road had not yet been paved. In these two images, the turnaround is viewed from opposite sides. (Both courtesy Oakland History Room.)

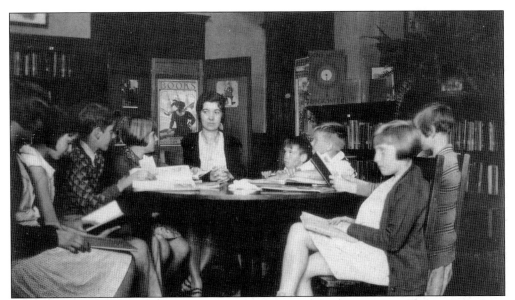

Librarian Faythe Elliott of the old Rockridge library seems to run a pretty tight ship. This photo was taken in November 1930. (Courtesy Oakland History Room.)

The library was once located at the corner of Miles and College, where BART parking exists today. Open until September 1987, this photo shows the library c. 1930. (Courtesy Oakland History Room.)

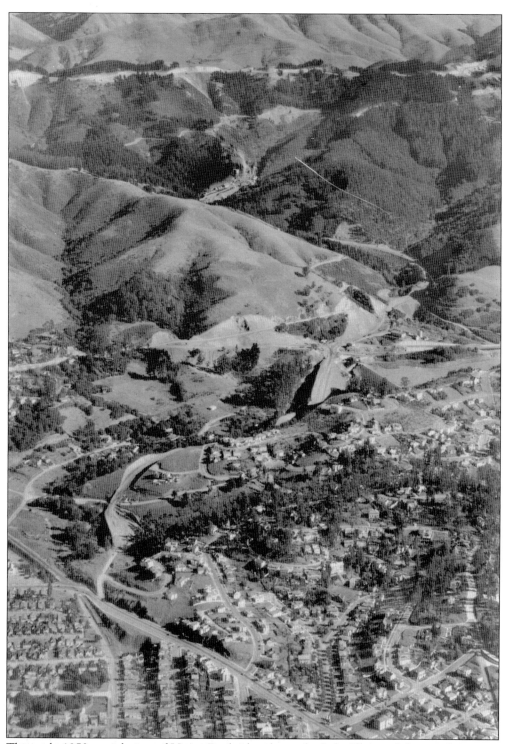

This early 1950s aerial view of Upper Rockridge shows the Lake Temescal dam in the center and the beginning of construction of Highway 24 and the Caldecott Tunnel at the upper edge. (Courtesy Fred Booker.)

Three

GLENVIEW AND TRESTLE GLEN

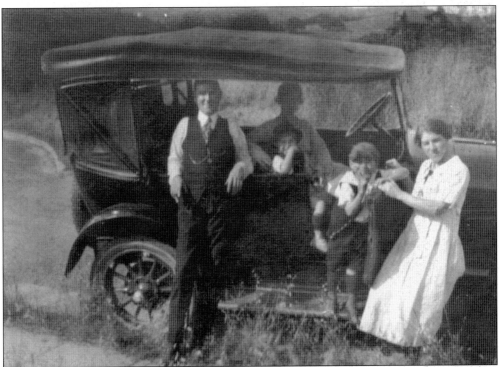

In this 1920 photo, a family proudly poses with their car at the dead end of Galvin Street in Glenview. Shown from left to right are Harold and Margaret Peterson, Bud Veirs, Mel Veirs, and their mother, Grace Veirs. Beyond them is the area that will be developed as Trestle Glen. (Courtesy Bud Veirs.)

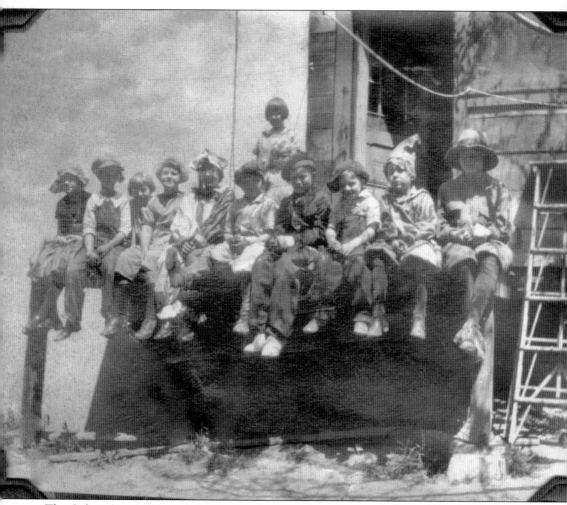

The Galvin Street Gang ruled Glenview in 1924. According to Bud Veirs (third from the right and now 87), the kids on Galvin Street would periodically wrangle with the kids on Elbert Street, who would "raid" his street. Once, he hid in a tree house; they barraged it with rocks. Not that his friends were angels: they hurled daubs of clay from the ends of sticks across the canyon at the other kids. (Courtesy Bud Veirs.)

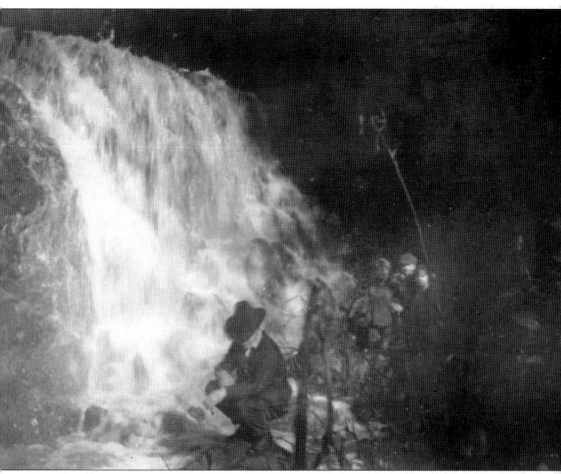

This photograph was taken in 1920 at the falls in Trestle Glen after a heavy rain. Bud Veirs's father, Dohrman, crouches on the rock, while Bud, Mel, and Aunt Doris hover in the background. Trestle Glen is largely restricted now but once ran freely. The creek's name was once Indian Gulch, named by American immigrants for the Huchiun people who lived alongside it. (Courtesy Bud Veirs.)

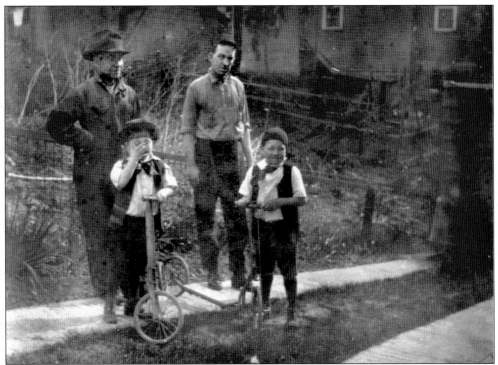

In this photo from 1920, the two men are dressed to overhaul a car, while the Veirs boys, Bud (left) and Mel, display their own form of transportation. (Courtesy Bud Veirs.)

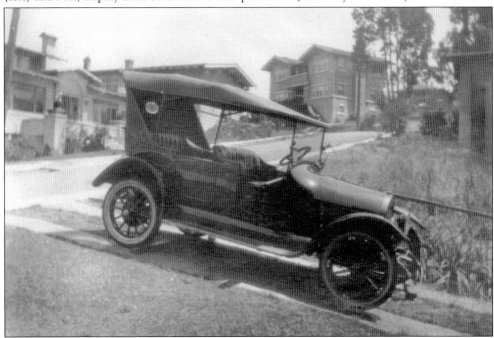

A 1921 view shows the car in question, the 1916 Overland, parked in the driveway at 1025 Galvin Street. Bud remarks that, when an adult, he bought a Model A Ford for $90 and would park with the rear wheels in the gutter so it wouldn't roll downhill. (Courtesy Bud Veirs.)

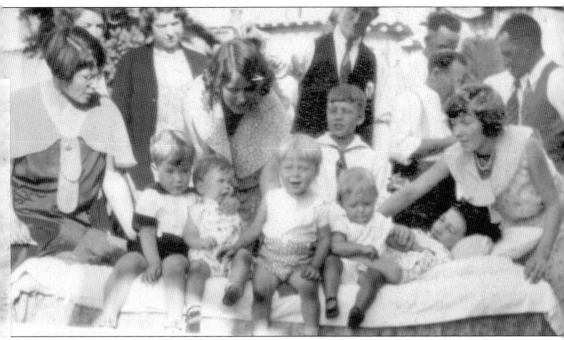

Bud Veirs's older brother Mel was ill with osteomyelitis, a bone infection he contracted when he was 10. Since he was bedridden and sometimes in a neck-to-ankle cast, a portable bed was built for him so that he could go outside. Mel was very popular with all the visitors. (Courtesy Bud Veirs.)

In this photo taken between 1910 and 1919, Park Boulevard is still a dirt road, and Corpus Christi Church has yet to be built upon this fenced lot. Today, one of the pillars still stands at

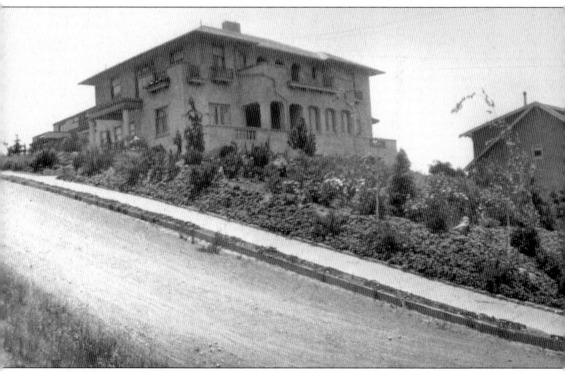

In this photo, a dog is coming up the barely inhabited stretch of San Sebastian Avenue to its intersection with Hollywood. This dog seems to appear in several Oakland History Room

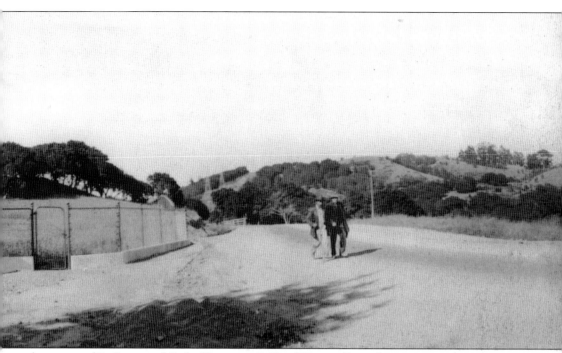

the corner of St. James and Park. (Courtesy Oakland History Room.)

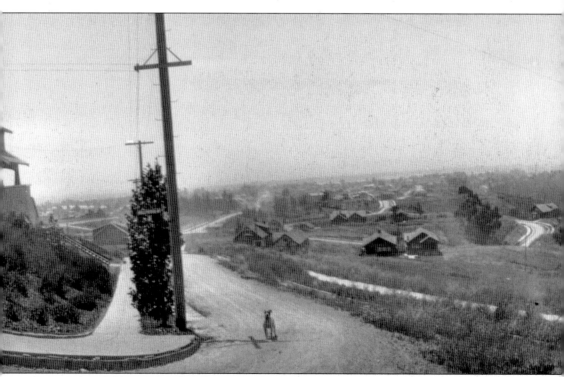

photographs of Glenview and Oakmore; perhaps the photographer set out one day with his trusty model, Fido. (Courtesy Oakland History Room.)

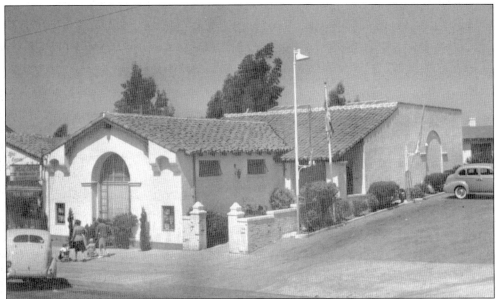

Glenview used to have its own branch library, and while the building still exists, it's now a piano and organ company. Residents lobbied for the library for seven years. Within 10 days of its October 1935 opening, 400 cards were taken out, proving its necessity. The library closed in 1981, but the piano store kept a small supply of books for a while so patrons could wean themselves. This photo was taken May 1939. (Courtesy Oakland History Room.)

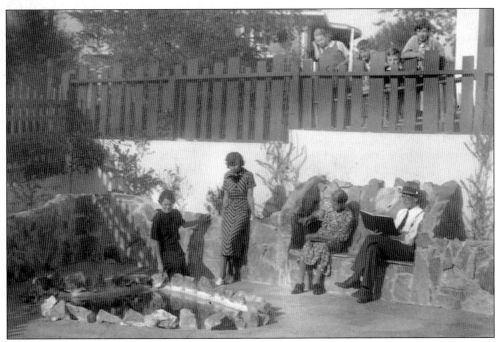

The Glenview library had a rear courtyard reached by a set of French doors containing flowering shrubs, inset stone benches, and a tiny decorative pool. Here, patrons enjoy their books while neighbor boys peek over the fence, October 1935. (Courtesy Oakland History Room.)

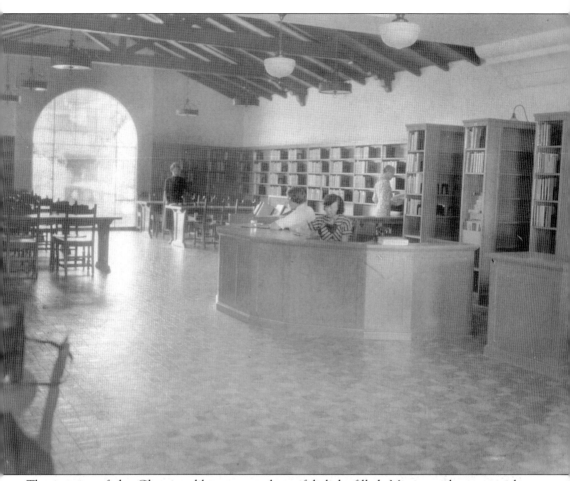

The interior of the Glenview library was a beautiful, light-filled, Mission-style space with wooden chairs with elaborately cut top slats. Despite the sunlight blazing from the large, arched window, the interior was dim from dust gathering on the light fixtures. Patrons complained of headaches due to the gloom, enough to warrant cases of "photophobia" being noted in the library records. In a 1949 library report, librarian Laura Barkley wondered how much of the drop-off in patronage was due to people gazing at "their shiny new television sets." She also mentioned problems in the late 1930s with noisy teenagers in the library (perhaps these were the infamous yet harmless Galvin Street Gangsters or their rivals). The children snapped rubber bands at people and asked insolent questions, such as this typical one to Barkley, "Why don't you dye your hair another color?" Barkley was librarian when the library opened and worked there for 21 years. This photograph was taken in October 1935, the month the library opened. (Courtesy Oakland History Room.)

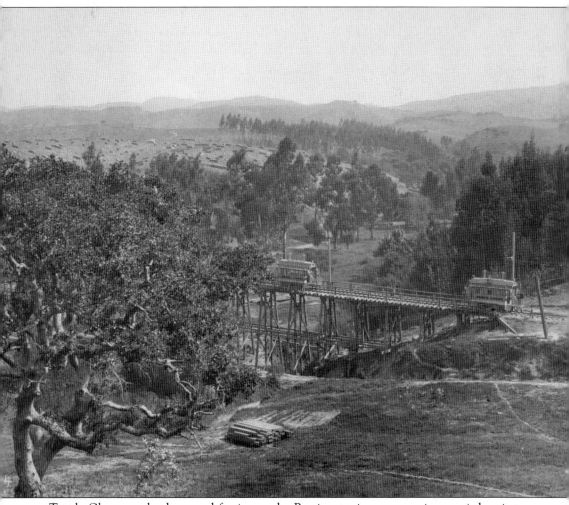

Trestle Glen was clearly named for its trestle. But its previous name, given to it by pioneers, was Indian Gulch. In the late 1800s Trestle Glen was a wilderness, boasting three lakes and a rushing creek. Huchiun Indians lived there in a village at the juncture of present-day Lakeshore and Trestle Glen Roads, but fell prey to missionaries and disease, two equally deadly entities for them. In 1893 a streetcar line was extended to the area to encourage day picnickers to buy land. A wooden trestle was built to carry the streetcar across the gulch, spanning from today's Holman-Grosvenor intersection and connecting to the Underhills Road–Grosvenor intersection. This picture was taken c. 1895. (Courtesy Oakland History Room.)

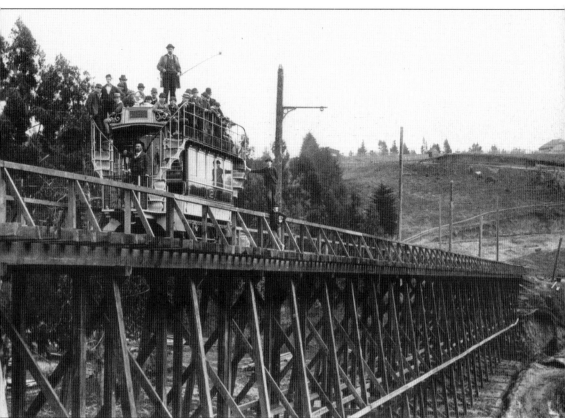

A traveler on the Trestle Glen streetcar's maiden voyage was none other than Mark Twain. Unfortunately, he doesn't appear in this *c.* 1895 photograph. The handsome double-decker streetcar had brass handrails. An Oakland Library History Room account states that women would avoid the rough manners of men by climbing to the second level, although it looks like these commuters were predominantly male. The streetcar was an important aid to the development of residential neighborhoods in Trestle Glen. The trestle was dismantled in 1906 when the line was rerouted. In general, Oakland's loss of streetcars is a mortifying story. The system was bought by a secret conglomerate of tire and auto manufacturers, including General Motors, Firestone, Mack Trucks and others, and quickly phased out. All over the country, streetcar systems were bought and dismantled (sometimes overnight), hastening the age of the automobile and all the attendant pollution, traffic, and fuel cost problems. In court, the cartel was found guilty but only made to paid nominal fines. (Courtesy Oakland History Room.)

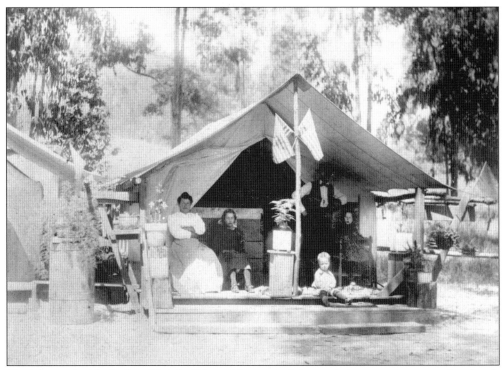

Picnickers who flocked to Trestle Glen either stayed in a semi-permanent structure (top), or visited more casually (bottom). Both pictures were taken c. 1910. (Courtesy Oakland History Room.)

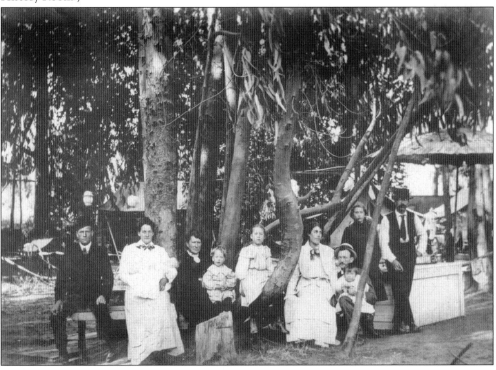

With only a few lonesome houses, Trestle Glen and Crocker Highlands were far more bucolic than they are today (above). Yet with more houses, a neighborhood is clearly developing, as shown in the c. 1918 photograph (below) of the corner of Rosal and Balfour Avenues, formerly called Lerida. (Courtesy Oakland History Room.)

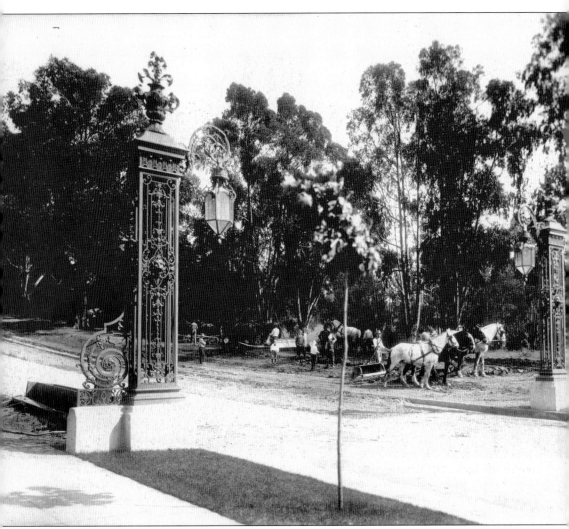

Horses grade Trestle Glen where it meets Lakeshore Avenue, *c.* 1918. If you look closely, you can see boys wearing newspaper hats. According to former Glenview resident Bud Veirs, a barn located at the other end of the street closer to Park Boulevard held the 40 horses used for grading. The wrought iron gates in this photo are still in place today, both on Longridge and Trestle Glen Roads. (Courtesy Oakland History Room.)

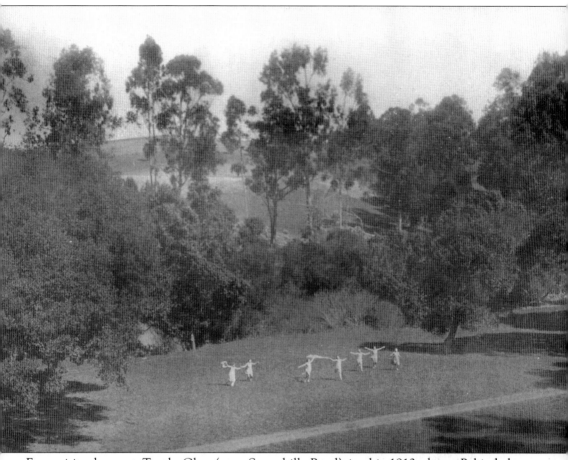

Free spirits dance at Trestle Glen (near Sunnyhills Road) in this 1912 photo. Behind the dancers is the canyon that, farther along, was spanned by the trestle, although by that time it had been dismantled. The flowing scarves and free-form posture of the dancers seems to suggest that they may have been influenced by Isadora Duncan, the iconoclastic dancer who grew up in Oakland. Duncan considered herself the "spiritual daughter" of Walt Whitman, and shared his exuberance for the simple blade of grass and nature's sensuousness. (Courtesy Oakland History Room.)

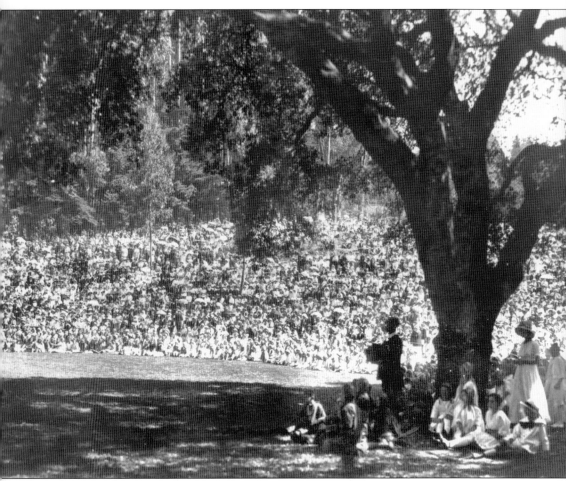

Trestle Glen's May Day festival certainly drew a crowd, as seen here *c.* 1912. Members of the crowd appear to be craning to look at something happening out of camera range. Are they watching the dancers shown on the previous page? The History Room has no conclusive evidence, but apparently some sort of performance is underway—perhaps a maypole dance. (Courtesy Oakland History Room.)

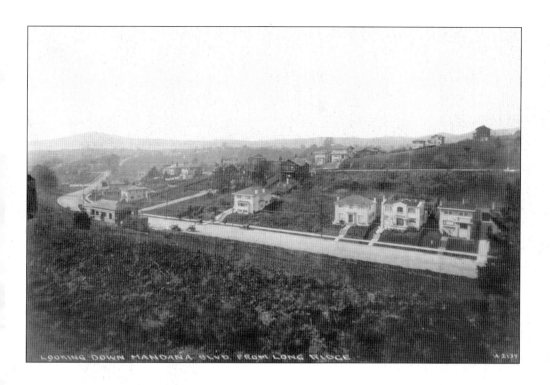

This is how it happens: first there is a space between two houses, and then the space is filled. The top photograph is from an undated Wickham Havens photo album, and the bottom photo is from the History Room files, c. 1918. Both were shot looking down Mandana Boulevard from Longridge Road. (Courtesy Oakland History Room.)

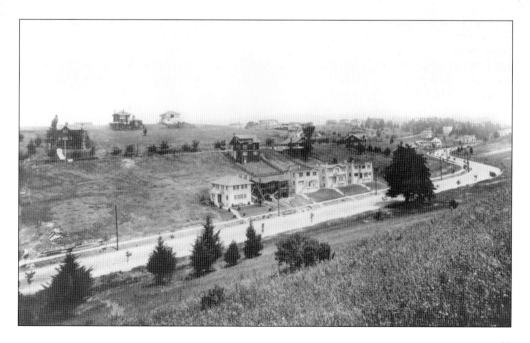

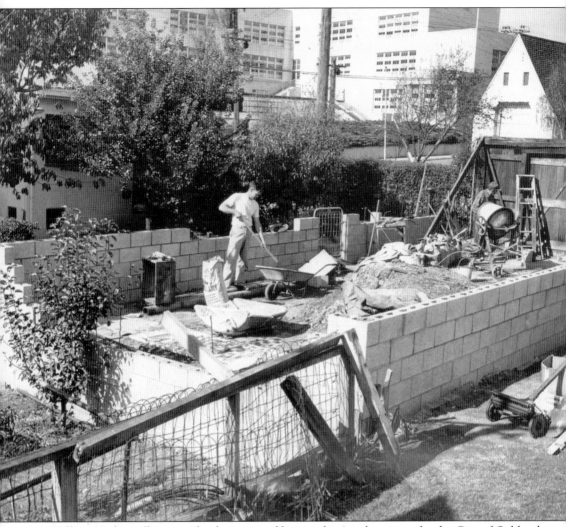

William Yochem illustrates the do-it-yourself principle. An electrician for the City of Oakland, he is shown here in the Glenview district building his own carport. At the cement mixer is his father, Paul Yochem, and in the background is Glenview Elementary School at LaCresta Avenue and Hampel Street. The *Oakland Tribune* ran an article on Yochem in 1959 and his "goal of gradually modernizing" his then 50-year-old home; this photograph appeared with that article. Yochem tore down his single garage and built a double carport, which still stands, for a grand total of $500. (Courtesy Claudia Yochem Neill.)

Four

DIMOND AND OAKMORE

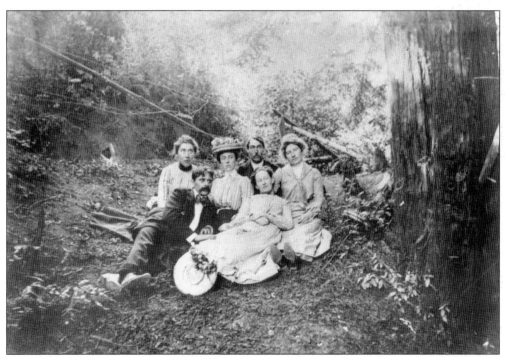

In this photo, a group of picnickers display their languid enjoyment of Dimond Park. The park, as well as the entire Dimond district, is named for Hugh Dimond, who came to California as a 20 year old with three children during the Gold Rush. In 1867 he purchased the acreage that includes what is now 12-acre Dimond Park. (Courtesy Oakland History Room.)

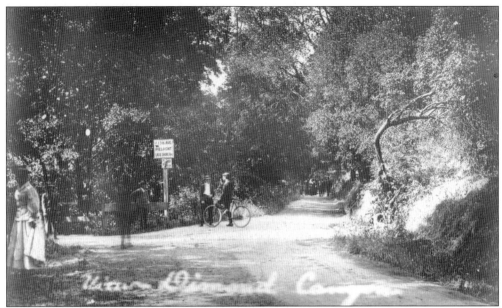

Dimond Canyon c. 1910 was a busy spot with locals taking their constitutionals or riding bikes (the term "bicycle" dates to 1869). The sign directs people toward Thirteenth Avenue, Piedmont, and Lake Shore Avenue, the latter being a fairly distant destination. Or, someone could turn right and go to Redwood Park, again a considerable journey. (Courtesy Oakland History Room.)

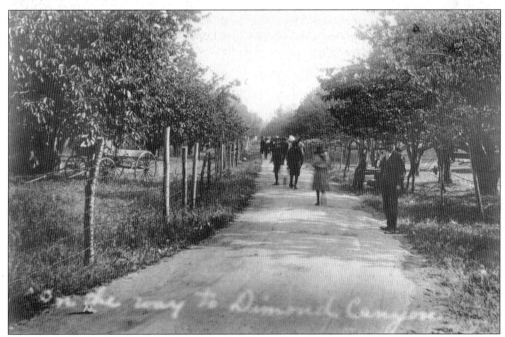

This c. 1910 photograph demonstrates not only the tremendous foot traffic through Dimond Canyon, but also the fruit trees and orchard ambiance of this area. (Courtesy Oakland History Room.)

The Peralta family's 1821 adobe, possibly the first real home built in Oakland, was toppled by developers in 1897. To build his 1897 cottage, Hugh Dimond used the same adobe bricks, which were later incorporated into the Boy Scout utility hut still standing in Dimond Park and shown here. It is amazing that the sun-dried clay has survived nearly two centuries of rain! Next to the structure is the massive, 200-year-old Dimond Oak. (Courtesy Oakland History Room.)

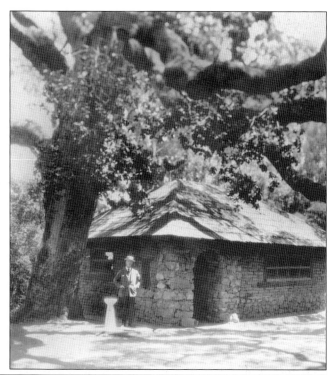

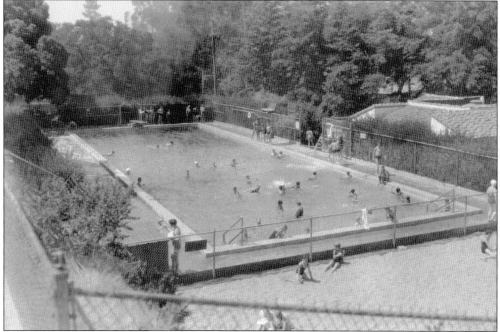

The Dimond Park pool was donated by the Lions Club. Work was undertaken in 1927; two years later the stock market crashed. Some members were unable to honor their financial promises and, of course, the cost of the project itself escalated. The debt was finally settled in 1932, well after the pool's 1929 dedication by Mayor John Davie. This 1933 photograph shows there was once a sand play area at the end. (Courtesy Oakland History Room.)

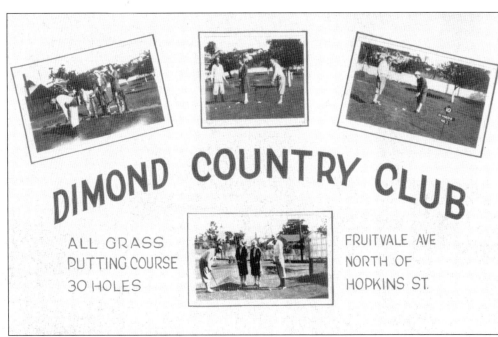

The Dimond Country Club may be a thing of the past, but this advertisement immortalizes the good form of these strokers. This 30-hole course was on Fruitvale Avenue at Hopkins Street (today's MacArthur Boulevard)—most likely where Dimond Park is today. (Courtesy Oakland History Room.)

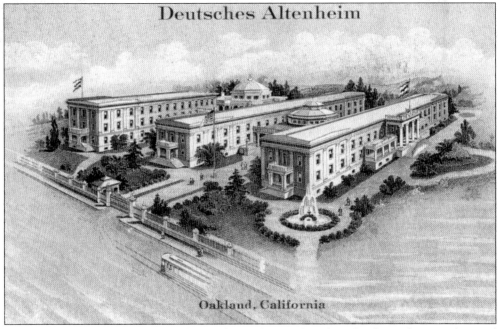

After a good game of golf, Oaklanders perhaps adjourned to the Altenheim for a quick round of whist. This 1952 postcard was mailed for 2¢, and the message on the back reads, "At the Altenheim whist party July 23. 1:30 coffee and cake. Score cards 50 cen." (Courtesy Oakland History Room.)

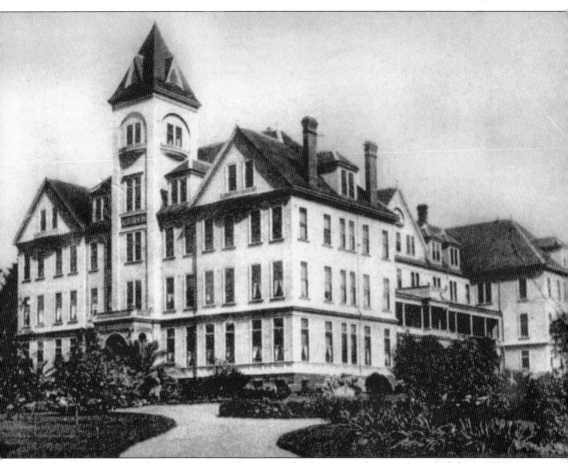

The impressive Altenheim retirement home was built over a three-year period from 1893 to 1896 and represented a grand venture for German Americans, who wanted a comfortable home to retire to. San Franciscan Adolph Sutro had offered the German Benevolent Society a free plot of land out by his estate on Ocean Beach, but the society decided instead to purchase six acres in Oakland for $6,000, on what was then called Hopkins Street (later renamed to honor Gen. Douglas MacArthur). Why spurn the free offer? Sutro Heights offered fog and cold winds, while the Dimond site was warm and sunny. It was also near orchards and biergartens, both compelling. After the dramatic 1906 earthquake, the Altenheim took in homeless San Franciscans—only to make its own residents homeless two years later when it burned to the ground. No one was injured, and the German community took in the residents until a new structure was built. San Francisco refugees were also put up in a tent at the southwest corner of Fruitvale Avenue and MacArthur Boulevard. (Courtesy Kevin Flynn.)

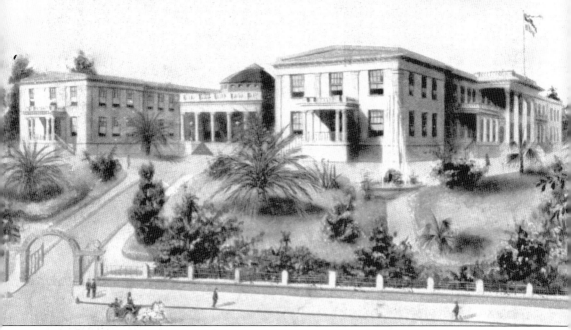

Deutsches Altenheim von San Francisco
FRUITVALE, CALIFORNIA

Today's Altenheim, built in 1909, is equally imposing: a grand, white, sprawling structure. This new version of the retirement home was designed by San Francisco architect Oscar Haupt, who won a design contest to earn the commission. The building is rated "A" (the highest rating) by the Oakland Cultural Heritage Survey, the city department that ranks all historic buildings. Although the Altenheim was initially built to house those of Germanic descent, it later became available to people of all nationalities. However, in May 2002 the Altenheim closed due to financial difficulties and its residents were given 90 days notice to find other housing. This postcard, mailed in 1912, was written entirely in German. (Courtesy Oakland History Room.)

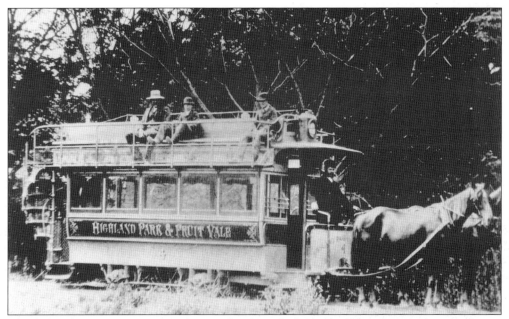

This horse-drawn streetcar, according to the note on the back of the *c.* 1890 photograph, ran from Thirteenth Avenue to East Eleventh Street to Dimond Canyon, and on to Beulah Park. The ride must have been unbelievably scenic. Back then, Dimond was not part of Oakland; it was annexed in 1908. (Courtesy Oakland History Room.)

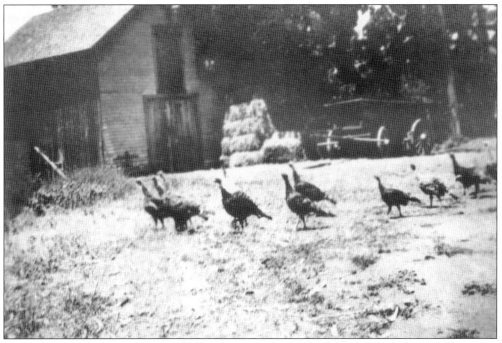

A local character named Dimond Ike writes on the back of this photo: "I raised these two turkeys by a setting hen in a nail keg. Ten birds out of 10 eggs. That was all keg and hen would hold." Ike herded the young turkeys around the creek and locked them up in the barn at night, all in preparation for Thanksgiving Day. (Courtesy Oakland History Room.)

Ralph Strathearn looks ready for a grounder on Boston Avenue at Hopkins Street (MacArthur Boulevard), in 1905. The family home is now the Dimond Pet Clinic. Strathearn was born in 1893. (Courtesy Oakland History Room.)

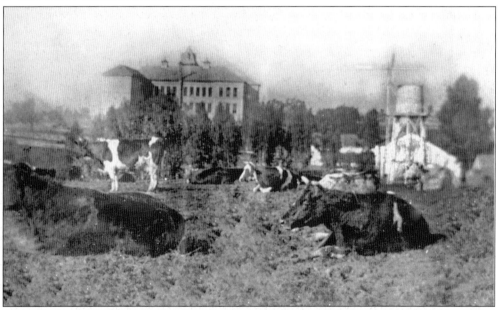

According to folklore, it must be about to rain, since most of the cows are sitting down. This is the Empire Dairy looking toward Fruitvale School, c. 1900. The five-acre dairy formed an L-shape from Boston Avenue east to Coolidge Avenue (then called Peralta Street), to Cuthbert Avenue and along School Street. The Empire cows were restless and bellowed during the 1906 earthquake, according to Oakland History Room documents. (Courtesy Oakland History Room.)

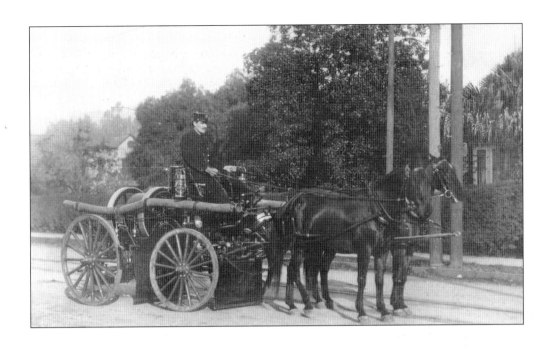

Capt. H. Walden of the Oakland Fire Department demonstrates a transportation milestone. In the top photograph he is seated upon the last horse-driven Dimond fire wagon. At bottom, he's at the wheel of Dimond's first motorized fire wagon. (Courtesy Oakland History Room.)

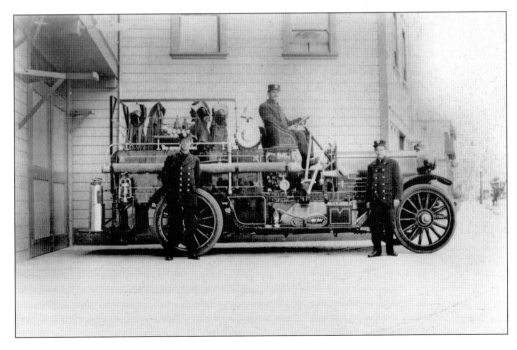

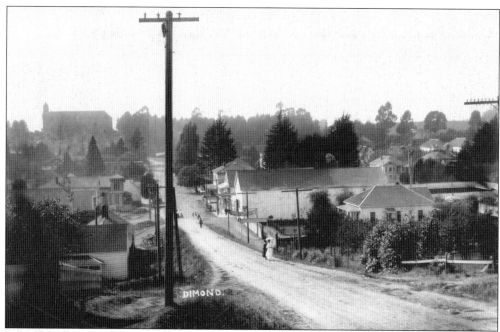

This stretch of MacArthur Boulevard should look familiar. It looks southwest along Hopkins Street (today, MacArthur) to its intersection with Fruitvale in the 1890s. In the distance is the original Altenheim retirement home. In this photo, people are walking away from the festivities advertised on the banners, which read, "Picnic Gardens–Private Parties–Music and Dancing." Today MacArthur is not so steep; grading in 1890 made the incline easier on horses and wagons. (Courtesy Oakland History Room.)

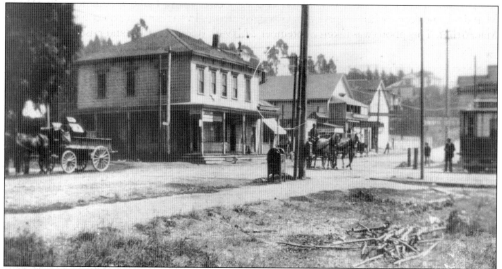

This photo shows the same intersection at a later date and from a different vantage point, looking northeast up MacArthur Boulevard. The large building with the porch is the Hermitage, a fancy French-cuisine restaurant and hotel whose dancehall girls did more than dance. Today it's a Radio Shack. Where the present-day post office stands, Bauerhofer's beer garden at one time put the "hops" back in Hopkins Street. There were several other biergartens in the neighborhood. (Courtesy Oakland History Room.)

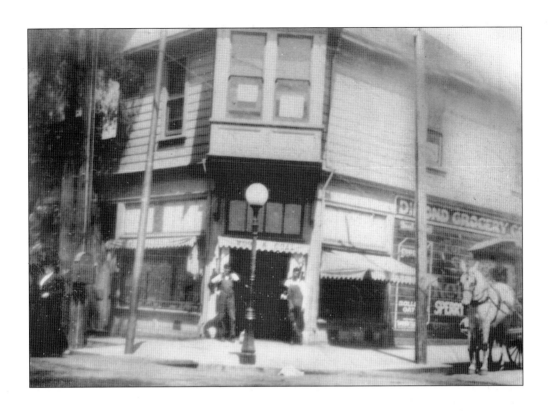

These pictures also show the intersection of Fruitvale Avenue and MacArthur Boulevard. The top photo is a 1917 view of the Dimond Grocery Store, where Bank of America now stands. Men flank the doors, while a horse-drawn buggy pulls up. In the bottom photo, a trolley rolls up MacArthur. This photo was taken September 27, 1940. (Courtesy Oakland History Room.)

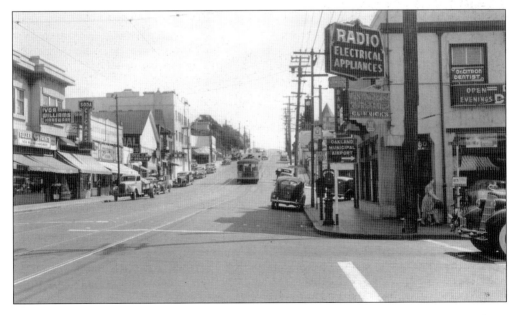

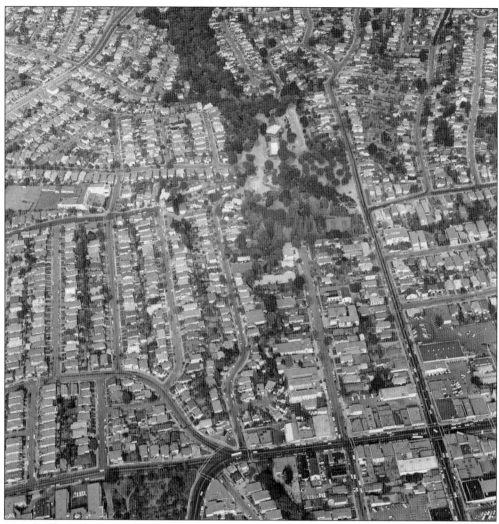

This 1967 aerial view shows certain landmarks in the Dimond District. The large greenbelt is Dimond Park, and MacArthur Boulevard is in the lower section with the Altenheim visible to the left. The greenbelt could have been much larger. In 1905 Mayor Frank Mott ordered civic architect Charles Mulford Robinson to create a plan for Oakland. Thanks to that plan, all the land around Lake Merritt is now public. Unfortunately, another grand scheme of Robinson's did not come to pass. He envisioned an enormous park stretching from the lake by way of Trestle Glen all the way up to Dimond Canyon. In 1946, the idea of extending Dimond Canyon was revisited, though on a smaller scale. Part of this improvement plan, created by superintendent William Penn Mott Jr., called for a dam above Leimert Bridge to create a six-acre "Inspiration Lake." The 800-acre park would have reached Joaquin Miller Park via a 20-mile-long scenic parkway. Alas, neither plan came to fruition. (Courtesy Oakland History Room.)

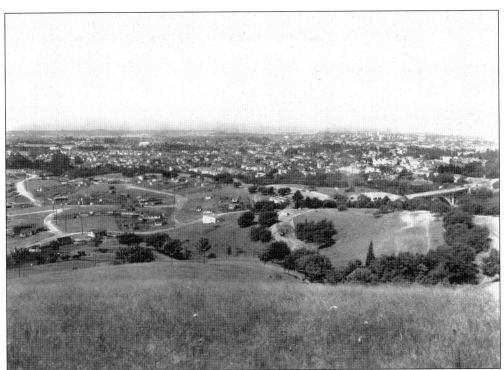

At the time this image was captured, Oakmore was just a sweet meadow with a great view of distant downtown Oakland. But the Leimert Bridge (at right) made a building boom possible. The bridge spans Sausal Creek, making this land accessible for development. Realtor Walter Leimert set up the subdivision of Oakmore Highlands in 1926, and the homeowners association he created is still very active today. (Courtesy Oakmore Homes Association/John Bosko.)

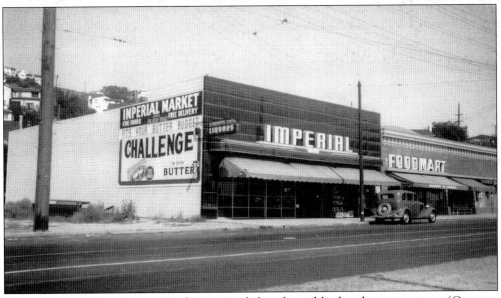

The Imperial Market is now Rocky's, a much-loved neighborhood grocery store. (Courtesy Oakmore Homes Association/Barry Bennett.)

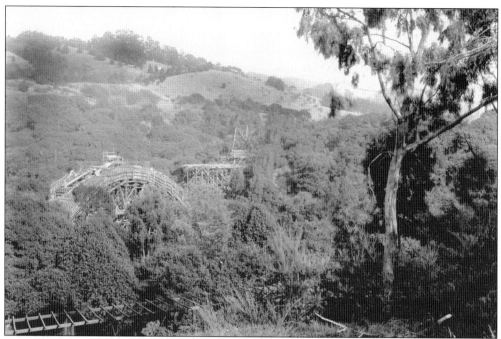

The Leimert Bridge is the totemic symbol of Oakmore. This 1926 photo shows the bridge being built. (Courtesy Oakmore Homes Association/John Bosko.)

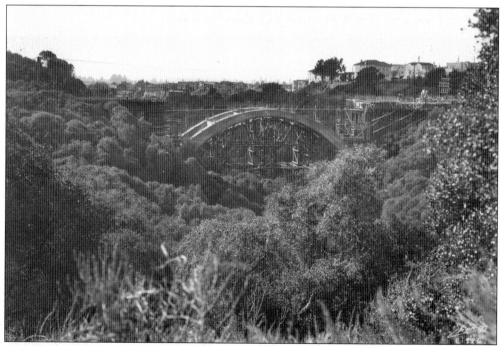

The next step in constructing the bridge is to pour the cement along the armature. The bridge is made of cement and steel, and was designed by George Posey, the man who also designed the Posey Tube. It spans 357 feet and is 117 feet high. (Courtesy Oakmore Homes Association/John Bosko.)

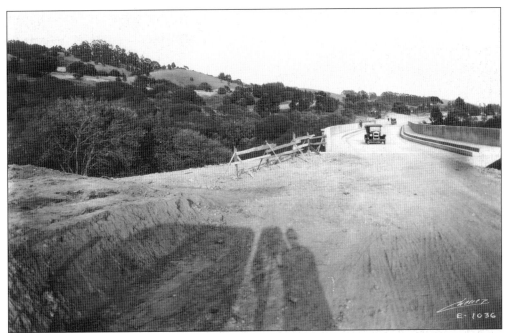

The final step is to use the bridge. This picture shows the photographer's shadow with the enormous old-fashioned box camera on a tripod. In September 2002, city landmark plaques were placed on the bridge thanks to a collaboration between the Oakland Heritage Alliance and the Oakmore Homes Association. A house tour was held in conjunction with the plaque's unveiling. (Courtesy Oakmore Homes Association/John Bosko.)

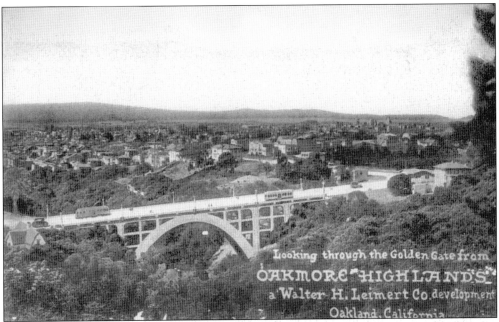

This postcard shows Leimert Bridge carrying the No. 18 streetcar across the canyon. After World War II the streetcar power lines were converted for street lighting, according to the Oakland Cultural Heritage Survey. (Courtesy Oakland History Room.)

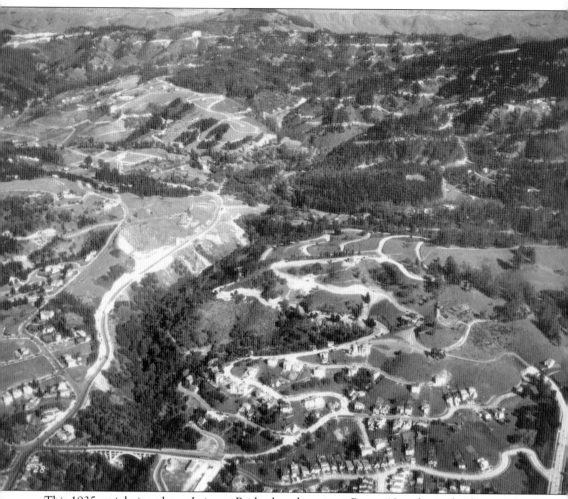

This 1935 aerial view shows Leimert Bridge but there is no Route 13 and very few houses along Estates Drive and in Montclair. In the 1800s, there was a reservoir on a bluff above the canyon in Glenview, just downstream from where the bridge was later built. At 60 feet long by 25 feet wide, the reservoir provided drinking water for the area. Another reservoir was built at Hopkins Street and Ardley Avenue in the Dimond District. It had underground caves where local boys gathered mushrooms to sell to San Francisco's famed Palace Hotel. (Courtesy Oakland History Room.)

Five

LAUREL AND REDWOOD HEIGHTS

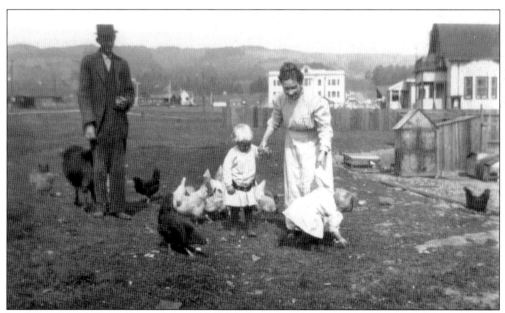

In this c. 1914 photo, Oscar Johnson and his wife, Emma, let children Roy (left) and Jennie scratch with the chickens. They lived on MacArthur Boulevard between Brown and Patterson Avenues. Behind Emma is the original Laurel School, which was subsequently torn down. Like many hill districts, Laurel arose because the Realty Syndicate ran a streetcar line there and sold lots to daytrippers. In fact, Laurel's original name in 1909 was Key Route Heights, named for Borax Smith's streetcar company. (Courtesy Jennie Johnson Hender.)

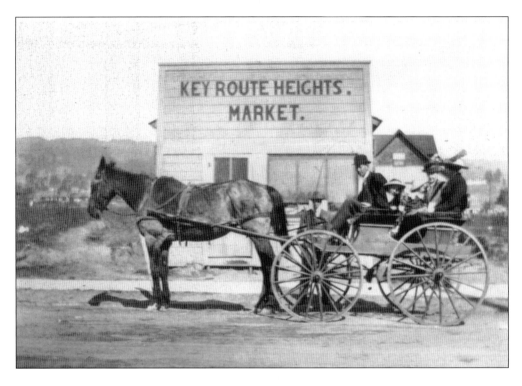

Oscar Johnson owned the Key Route Heights Market located at 3926 Hopkins Street (MacArthur Boulevard). The market opened in 1912 and closed in 1915. Thereafter Johnson took up dairy work although his wife advised, "You'll work twice as hard and make no more." Perhaps she was right: he died in 1917 at age 41. Jennie Johnson Hender, the source of this information, was born in 1912, the year the market opened. (Courtesy Jennie Johnson Hender.)

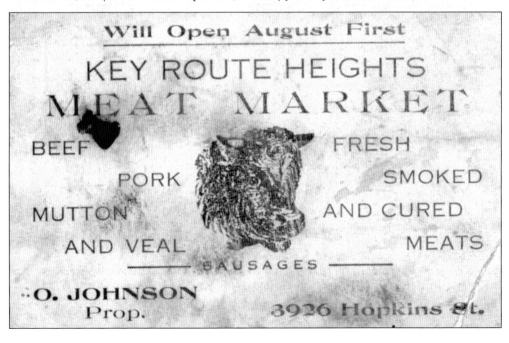

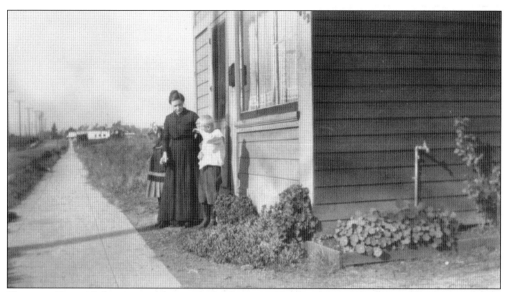

Here are Emma Johnson and her two children, on Hopkins Street looking toward Thirty-fifth Avenue. Jennie Hender, approximately seven years old in this picture, remembers that her brother cried and did not want his picture taken. (Courtesy Jennie Johnson Hender.)

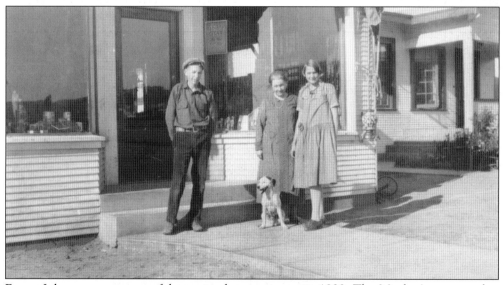

Emma Johnson was resourceful, starting her own store in 1923. The Maple Avenue market was originally a residence; Hender (at far right) says it's now one again. When Hender was in her mid-teens around the time of this c. 1928 photograph, she told someone, "You know, someday there's going to be a bunch of houses on that hill." They laughed. (Courtesy Jennie Johnson Hender.)

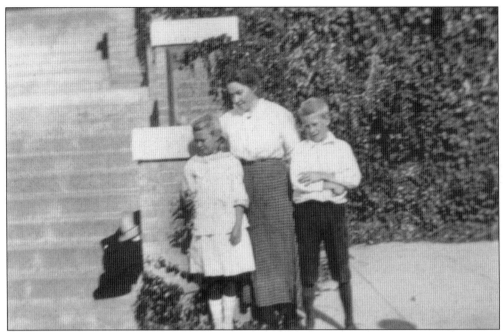

Jennie, Emma, and Roy Johnson pose on the steps of Laurel School, which Jennie attended until the fifth grade. The school opened in 1910 and was later torn down. The current school was built on its site. (Courtesy Jennie Johnson Hender.)

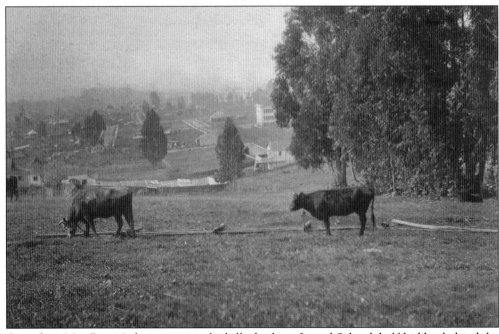

Cows from Miss Power's dairy graze on the hillside above Laurel School, half-hidden behind the trees. Hender remembers Miss Power driving her cows with a stick, dressed all in black. Boys called her a witch. The dairy was on Patterson Street, which Hender recalls had a eucalyptus grove. (Courtesy Oakland History Room.)

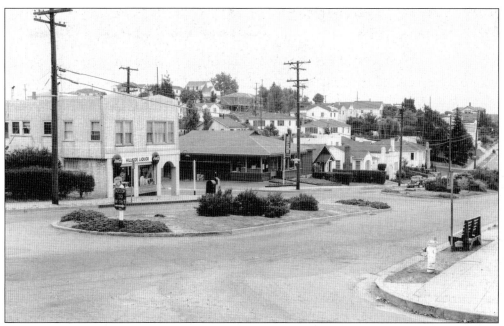

This August 1951 Laurel Street scene shows that construction is still underway as a house goes up in the background. The main street here is High Street and the street running between Hillside Liquor and Jack's Food Shop is Hyacinth. This photo was taken from Tompkins Avenue. (Courtesy Oakland History Room.)

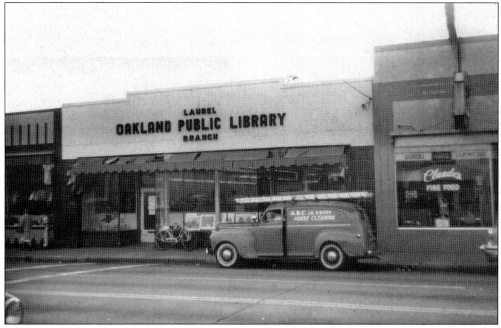

Laurel used to have its own library branch, opened 1954 in a storefront at 3725 MacArthur Boulevard. It incorporated the scant collection of a 1922 Allendale branch. In 1975 the library moved to 3625 MacArthur and was eventually abandoned in favor of the Dimond branch. This photo was taken in January 1957. (Courtesy Oakland History Room.)

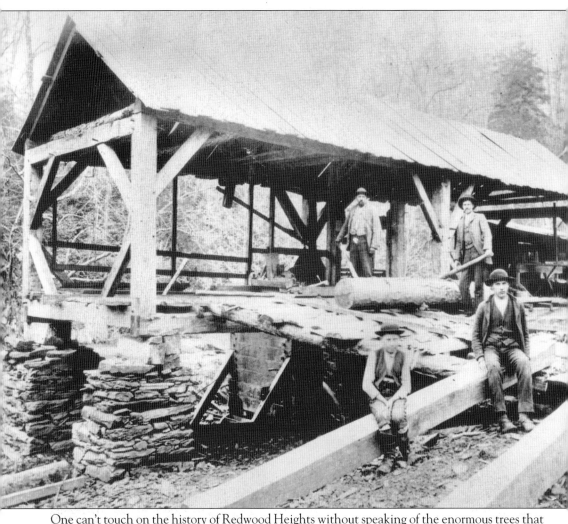

One can't touch on the history of Redwood Heights without speaking of the enormous trees that once clustered there. Beginning in 1840 and continuing for the next 20 years, these towering, fragrant trees were harvested. One redwood had a 33.5-foot diameter, yet it too succumbed to the saw. This sawmill on the Palo Seco Creek is credited with being one of the first steam-powered mills in the region. It operated between 1849 and 1854. The Palo Seco Creek still runs through Joaquin Miller Park and funnels into Sausal Creek. There were at least nine other sawmills in the area, one run by waterpower. The home of Moses Chase, the first squatter on Peralta land, is said to have been built from the timbers of this mill. The now-endangered California condor was a frequent sight back then; in one hour, 50 were reportedly counted. Despite their bird-watching, the loggers were a rough sort, often ship deserters, who performed their own vigilante justice, lynching horse thieves and cattle rustlers. In place of the clear cut redwoods, eucalyptus groves were planted, a decision with severe repercussions. A century and a half later, they fueled a devastating wildfire. (Courtesy Oakland History Room.)

Woodminster Amphitheater, cresting the hills off Joaquin Miller Road, was designed as a memorial to California authors. It was erected by WPA workers from 1933 to 1936 but wasn't dedicated until 1941. Due to World War II blackout regulations, the lights weren't turned on until 1944. The amphitheater boasts a series of cascades, with sinuous stone stairs connecting seven pools. At full capacity, the cascades move 1,000 gallons of water a minute down 100 feet of drop. The middle pool was built to run through a nine-minute light show; its fountain was created for the Golden Gate Exposition on Treasure Island and was moved after the expo closed. Woodminster seats roughly 3,000 people. (Courtesy Oakland History Room.)

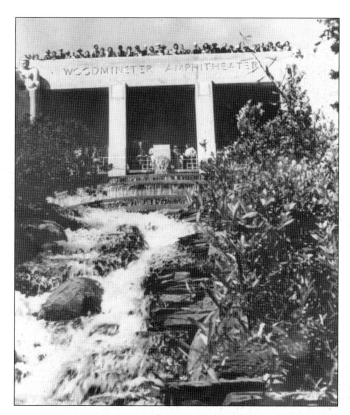

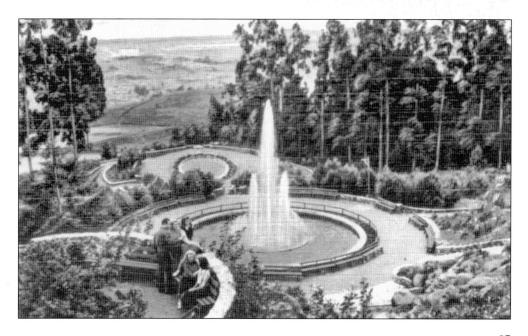

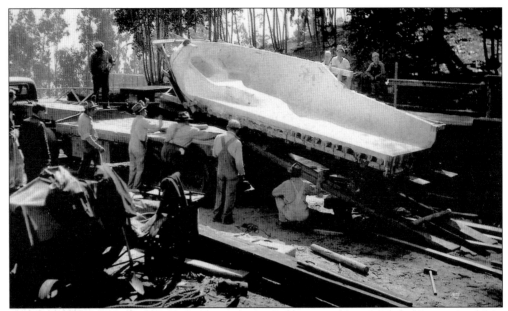

Workers in 1941 take a form off the truck that will be used to make one of the two colossal 18-foot figures ornamenting the front of the amphitheater. Sculptor Franz Sandow created the figures, one of which is said to depict a mother and daughter and the other a father and son. (Courtesy Oakland History Room.)

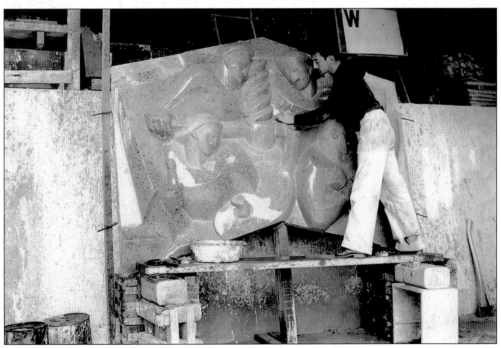

This photo shows Sandow working in May 1941 on the panel that is now installed to the right of the colossi. The two figures on the top of the sculpture appear to be operating a drill, while an artist holds a paintbrush and palette on the bottom left and a chiseler works on the bottom right. (Courtesy Oakland History Room.)

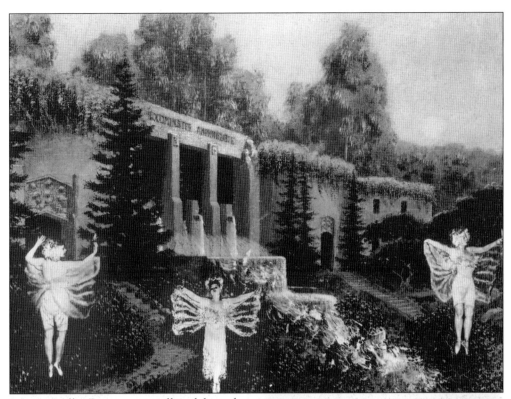

Joaquin Miller Day was annually celebrated with plays written by and starring Juanita Miller, ostensibly to honor her poet father. These shows involved fairies, flowers, and rainbows, all dramatizing events from the Millers' lives. This doctored photograph shows three views of Juanita as "the forgiven fairy" against the backdrop of the top of the cascades from a 1948 production. One of the colossi is visible at the top of the structure. (Courtesy Oakland History Room.)

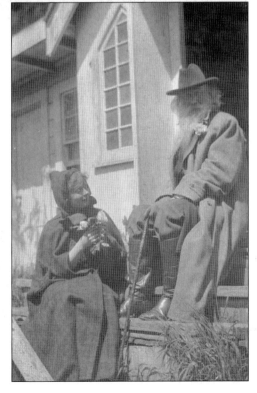

Just down the road from Woodminster is the home of Joaquin Miller, the "Poet of the Sierras." Miller, his mother, and his daughter lived in three neighboring cabins that still stand by the side of the road named for him. Daughter Juanita, also a poet, shows a flair for drama in this posed photo with her father. It is labeled "At home after illness, 1910." (Courtesy Oakland History Room.)

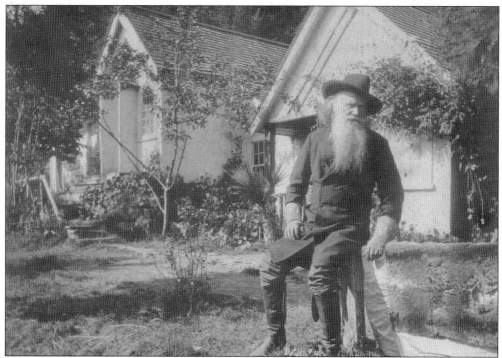

This *c.* 1904 photo shows Miller at his "Abbey" at its height, well-maintained with pleasant grounds. Miller was known for his distinctive beard and penchant for boots. He was born Cincinnatus Heine Miller in Indiana in 1841. (Courtesy Oakland History Room.)

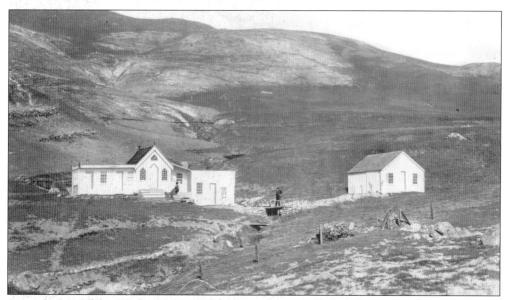

An early view of the "Hights" (as Miller deliberately misspelled it) shows a treeless terrain. Two figures can be made out, one standing on the footbridge and one on the porch. Miller planted 70,000 trees on his land and created the wooded park residents enjoy today. The Hights was built in 1886. (Courtesy Oakland History Room.)

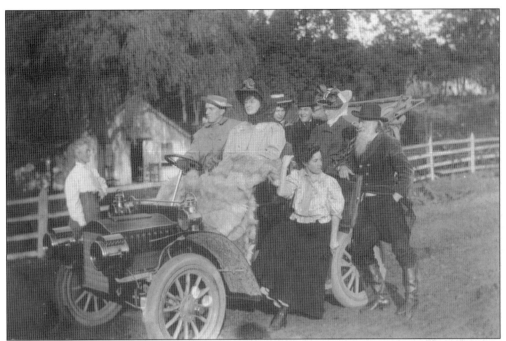

Joaquin Miller is at far right in his trademark boots as this group prepares to go motoring. (Courtesy Oakland History Room.)

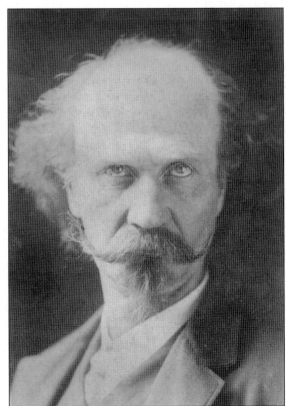

Here's a rare photo of Joaquin Miller without a full beard. The cryptic notation on the back reads, "Taken just after recovering from a severe case of whooping cough he contracted when carrying a strange child across Fifth Avenue, NYC in 1885." (Courtesy Oakland History Room.)

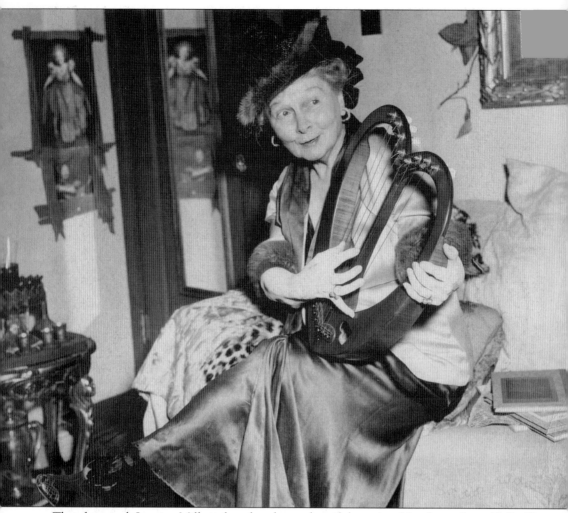

The theatrical Juanita Miller plays her heart-shaped harp in this photo from 1949. She invented and patented the instrument because she felt that thinking of her father, who died in 1913, was like playing the harp of her heart. Juanita's love life was quite remarkable. She was reportedly wooed by Rudolph Valentino, who played guitar beneath her window. She married and divorced twice, each time nicknaming her husband "Juan" so his name would match hers. Her second wedding ceremony began, the 1921 *San Francisco Chronicle* reported, with Juanita lying as if dead, with flowers surrounding her and candles at her head and feet. Her groom appeared and "embracing Juanita's cold form with an ecstatic kiss, electrified her earthly being and brought her back to mundane life." The ground at the nuptials was consecrated with goats' blood. When Juanita died in 1970, her estate consisted of a scant $21,670 and the yellow and white diamond ring reputedly given to her father by Queen Victoria in 1870 when he visited England. The flawed four-carat piece is now in the Oakland Museum of California. (Courtesy Oakland History Room.)

In this photo, Juanita stands outside her father's log cabin, apparently the first structure built on the Hights. (Courtesy Oakland History Room.)

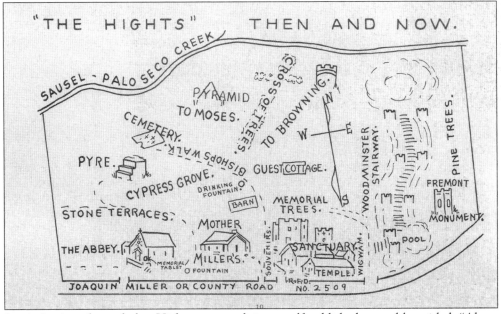

Juanita's site plan of the Hights appeared in a self-published pamphlet titled "About 'The Hights.'" Woodminster is marked on the map, as are various whimsical monuments her father erected, which still stand today. At one point, traffic to the site was so fierce that Juanita opened a gift shop; hence the marking "Souvenirs" on the map. (Courtesy Oakland History Room.)

This photo shows the Funeral Pyre, one of the monuments Miller erected. He actually intended it to be used after his death, but as this conflicted with city regulations, the mourners settled for scattering his ashes over the monolith. (Courtesy Oakland History Room.)

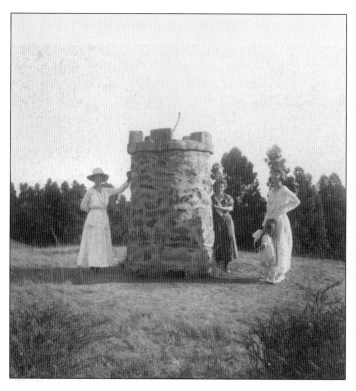

Another monument is the Tower to Browning. Joaquin Miller traveled with his friend, poet Robert Browning, throughout Italy. The other monuments are a Pyramid to Moses and a battlement honoring trailblazer John C. Fremont, for whom Fremont, California, is named. In 1942 Juanita commissioned a statue of Joaquin Miller on horseback, which stands on the site of Joaquin's mother's cottage. (Courtesy Oakland History Room.)

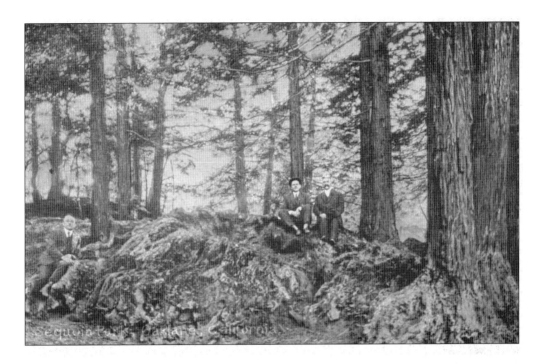

These two postcards show the peaceful respite offered by Sequoia Park. Where is Sequoia Park? It has now been subsumed by the larger Joaquin Miller Park, but its address used to be 3550 Joaquin Miller Road, near Robinson Drive. (Courtesy Oakland History Room.)

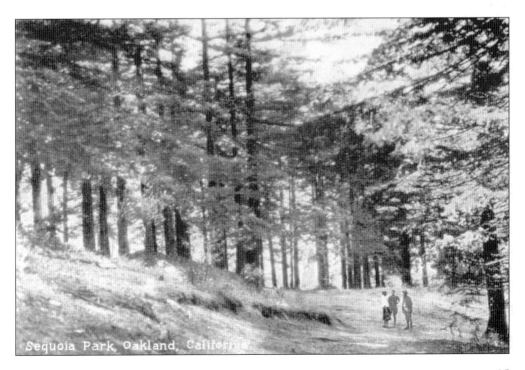

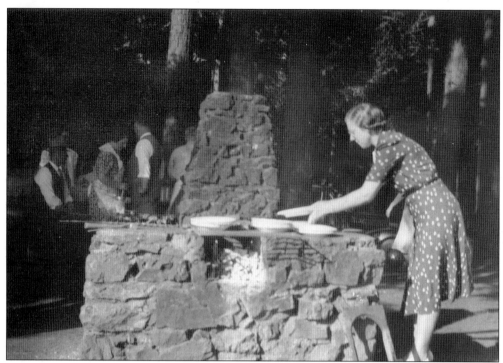

A woman takes her barbecuing seriously in this photo taken at Sequoia Park in October 1939. (Courtesy Oakland History Room.)

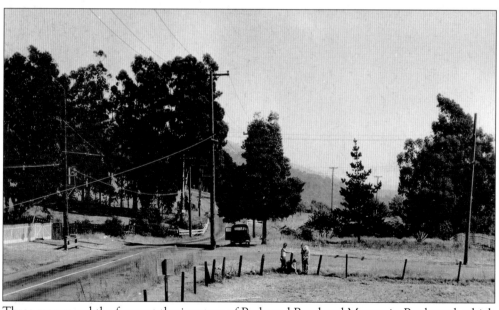

Three men mend the fence at the juncture of Redwood Road and Mountain Boulevard, which used to dead end at Redwood. This 1930s photo was taken at today's intersection of Monterey Boulevard and Redwood Road. (Courtesy Oakland History Room.)

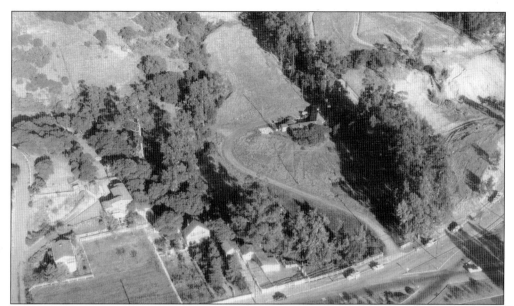

This is the Luther Lincoln residence and environs in November 1956, today the site of the Lincoln Square Shopping Center. Oakland nearly had its own gold rush here. In the 1880s, pyrite (fool's gold) was discovered, and for a few ecstatic, heart-stopping days, Oaklanders thought they had the equivalent of Sutter's Mill. Alas, the gold was nonexistent, but the views in Redwood Heights are now about as valuable. (Courtesy Oakland History Room.)

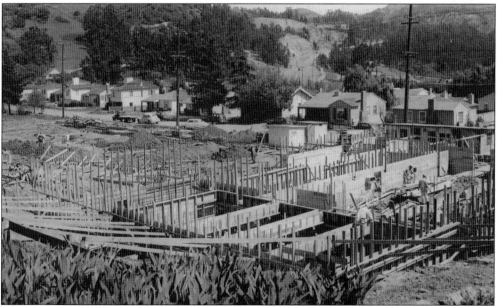

This c. 1949 photo shows Redwood Heights Elementary School being constructed on Thirty-ninth Avenue; in the distance is Redwood Road. The area was filled with wood-frame houses at the end of long, gravel driveways. All but one was torn down; it remained for the building contractor. After construction, it too was demolished. Redwood Heights School began in 1933 as a one-room school; the new building, shown here, housed 250 students in 11 classrooms. (Courtesy Oakland History Room.)

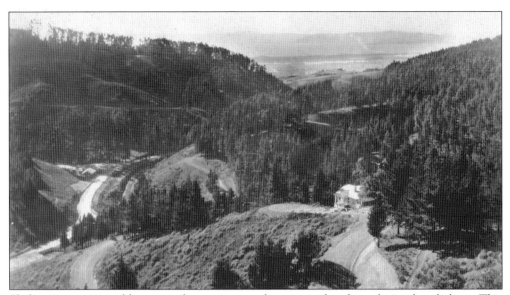

Skyline, as one would expect, has a spectacular view of—what else?—the skyline. This photograph from a Wickham Havens album shows a panorama of the hills all the way out to the bay and San Francisco in the distance. (Courtesy Oakland History Room.)

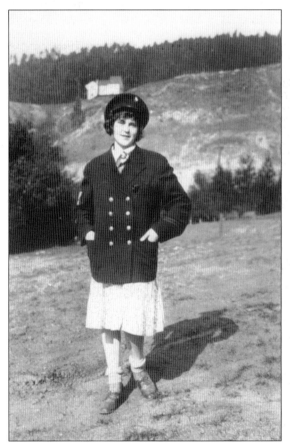

Hellene Miller poses in a friend's uniform at the Oakland Nature Friends grounds on Butters Drive. This club is connected to the European club of the same name begun in Vienna in 1895. The Nature Friends hike and enjoy the natural world. Oakland's club began in 1921. At that time, the surrounding hillsides were grasslands rather than forest as they are today. (Courtesy Nancie J. Glenk Janiak.)

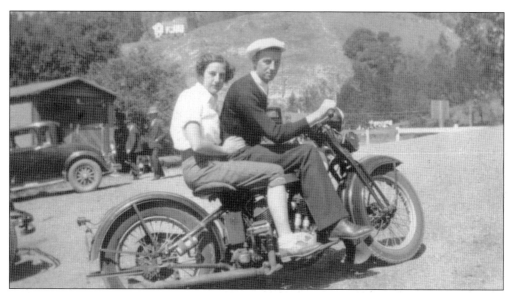

In front of the hillside at Oakland Nature Friends property, Irene Korn and her friend George perch on a Harley Davidson in April 1933. This is the same year that Hitler banned the Nature Friends in Austria; today there are 600,000 members in 25 countries around the world. Oakland's club has about 200 members and is no longer strictly German-speaking. (Courtesy Nancie J. Glenk Janiak.)

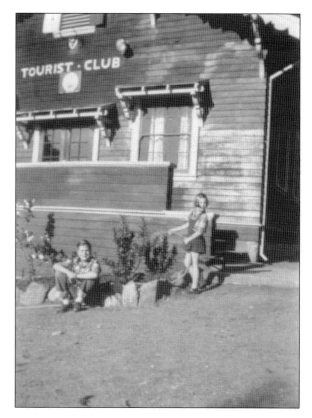

Nancie Glenk waters the plants outside the Oakland Nature Friends clubhouse while her brother Bob relaxes. Many of the clubs, including Oakland's, built clubhouses to help members tour the countryside, hence the associated name "Tourist Club." In Germany alone there are 430 clubhouses; California has only a handful. Glenk Janiak says, "German citizens who come to the Bay Area know about [the clubhouse], but people who live here don't." (Courtesy Nancie J. Glenk Janiak.)

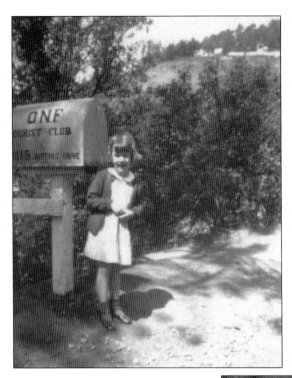

Nancie Glenk stands in front of the Oakland Nature Friends mailbox in March 1949. Her parents were live-in caretakers of the club from 1947 to 1956. The photo's notation says that it's her birthday; perhaps she was checking the mail for birthday parcels. (Courtesy Nancie J. Glenk Janiak.)

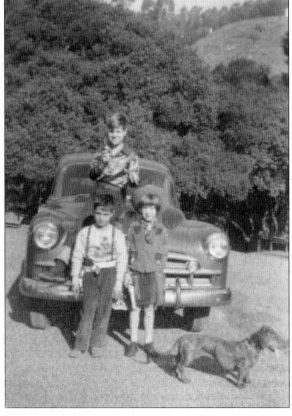

Bob Glenk (sitting), Dennis Vasvo, Nancie Glenk, and low-slung steed Mitzi shoot 'em up at the Oakland Nature Friends club in January 1950. Vasvo's family had the first TV set in the hills, and Nancie and Bob would hike over to watch *The Howdy Doody Show*. On the way home, Bob would turn off the flashlight and "ditch" his sister. (Courtesy Nancie J. Glenk Janiak.)

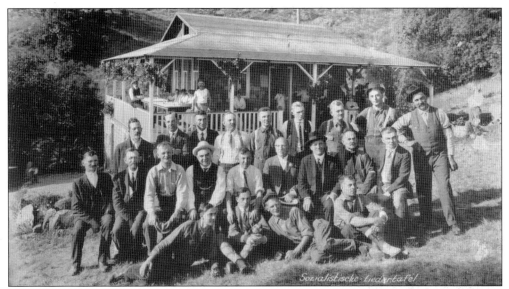

This June 1922 view shows the Nature Friends clubhouse in the grassy (now wooded) hillside. The club originally allowed only members who belonged to a workers' union, hence the photo's label "Sozialistische Liedertafel." The club's goal—to ensure that hiking lands were available to all classes—springs from Socialist roots. The union requirement also guaranteed that members had the skills to build and maintain their clubhouses. (Courtesy Oakland Nature Friends.)

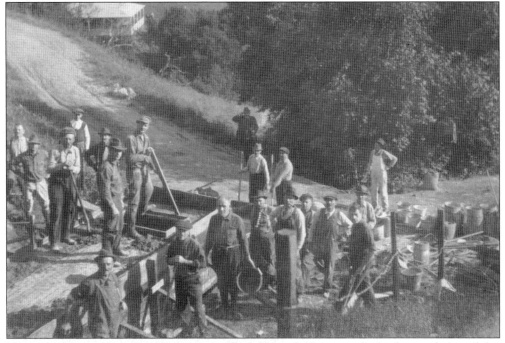

Here, members work on the club's water well, with the clubhouse in the background. A workday is held every month to clean and maintain the premises. Not only do members know how to work, they know how to celebrate: they have held events such as Sommerfest and Oktoberfest every month since 1920. (Courtesy Oakland Nature Friends/Erich Fink.)

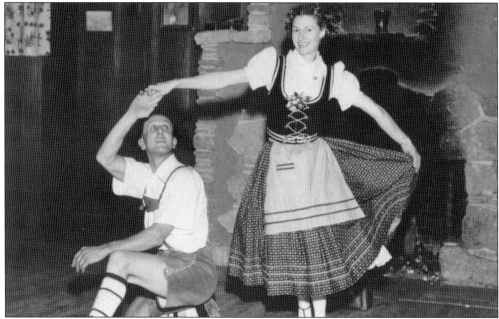

Alpine dance came to the "Naturfreundehaus" in 1951, when a Bavarian-born caretaker taught traditional dances. Frank and Ann Uher, seen here, were well-known Schuhplattlers. The Schuhplattler dates to the 1300s and mimics the mating dance of a wood grouse, the Auerhahn. The male dancer slaps his feet and Lederhosen, like "flapping his wings." The woman spins around the man, like the female Auerhahn prances. Behind them is the club's lovely fireplace. (Courtesy Oakland Nature Friends.)

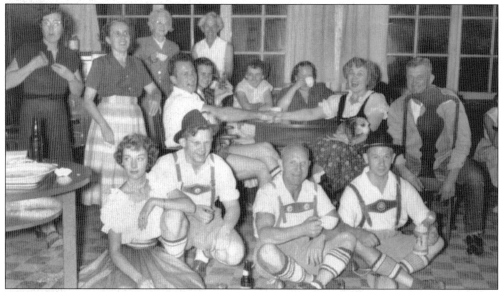

These members take the call to Gemuetlichkeit seriously—letting the good times roll. During Prohibition, resourceful members made their own beer and the club attracted new members who drank the beer on the outdoor dance platform. They would take the Key System streetcar to Fruitvale and then walk up Peralta Creek; the return trip must have been a good, sobering hike. This image is undated. (Courtesy Oakland Nature Friends/Erich Fink.)

Six

MILLSMONT AREA

This stereoscopic view shows women and a boy enjoying the rustic beauty of Leona Heights, c. 1900. (Courtesy Oakland History Room.)

This charming panorama shows Seminary Avenue and Laird Avenue in 1925. A car sits in the

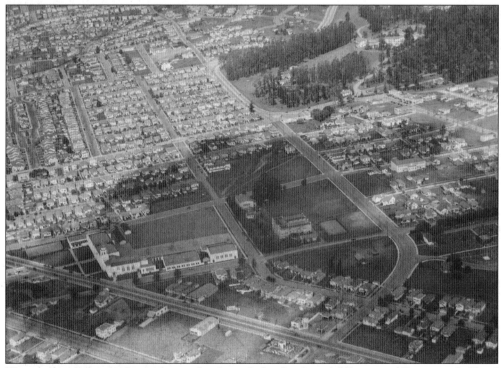

This undated aerial photo shows the lay of the land in Millsmont. (Courtesy Oakland History Room.)

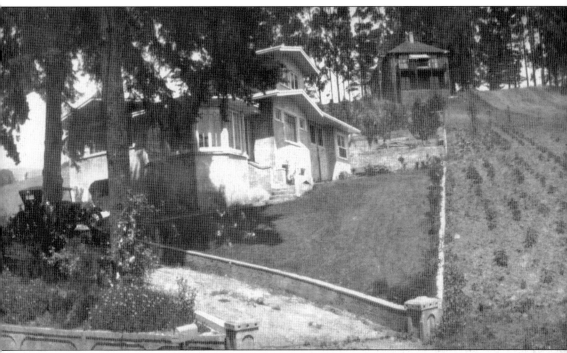

driveway while another motors around the corner. (Courtesy Oakland History Room.)

Here at Picardy Drive and Seminary Avenue, birch trees reign in a photo from December 1947. For many years residents on Picardy have lit their houses beautifully at Christmas and people drive slowly by to admire the decorations. (Courtesy Oakland History Room.)

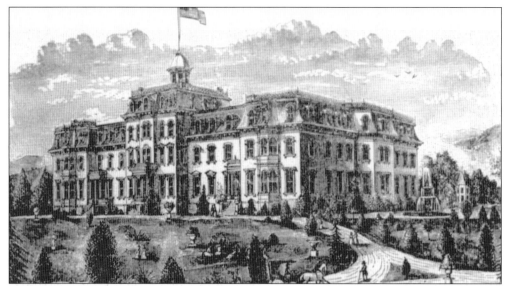

Mills College began in 1852 as the Young Ladies Seminary in Benicia and is the second oldest women's college in the United States. It is named for Cyrus and Susan Tolman Mills, who bought the school and relocated it in 1870 to the township of Brooklyn, which Oakland annexed two years later. The land had once been the site of an Indian village, with bones of the dead providing a mute testimony to its existence. (Courtesy Oakland History Room.)

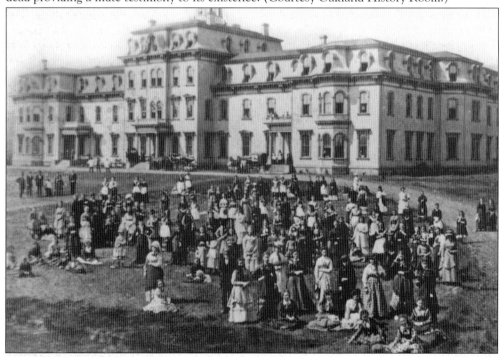

A glass cupola that once perched atop Mills Hall, 75 feet above ground, was used as an observation tower to study nature. It was dismantled for safety reasons. The hall was initially heated by steam and lit with gas, a new technology at the time. The rooms were large, high-ceilinged, and had running water, another innovation. Alumnae remember walking on the wide ledge outside the third-floor windows, using it as an exterior "hallway." (Courtesy Oakland History Room.)

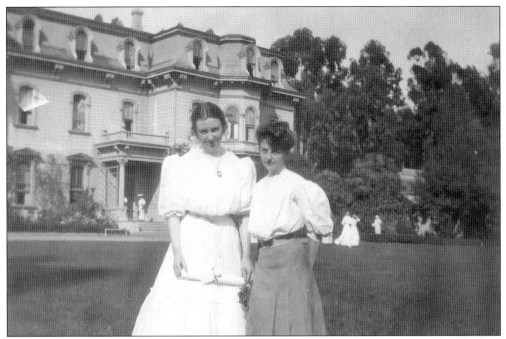

Two students stand in front of Mills Hall, which originally composed the entire college. The hall was built of local wood from a Brooklyn lumberyard, brought to the site by draft horses. The brickwork was by Oakland's Remillard Brothers. Vegetable gardens, an orchard, and a dairy made the campus self-sufficient. Originally white with a red roof and blue cupola, the hall was later painted brown. (Courtesy Oakland History Room.)

This postcard shows the main entrance to Mills College. Although Mills is still open only to women for undergraduate study, co-ed graduate programs were established in 1920. The school's library contains a Shakespeare First Folio, first drafts of manuscripts by Virginia Woolf, and a Mozart manuscript. (Courtesy Kevin Flynn.)

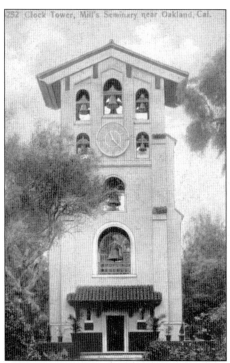

Julia Morgan designed El Campanil in a Mediterranean-Craftsman style. The tower holds the bells from the 1893 World's Columbian Exposition in Chicago. El Campanil was funded by Borax Smith, Oakland's own entrepreneurial millionaire who played a huge role in the settling of the hills. Another local architect, Bernard Maybeck, created a general plan for the campus, only partially realized. Mills has many beautiful buildings, including four designed by Julia Morgan. (Courtesy Kevin Flynn.)

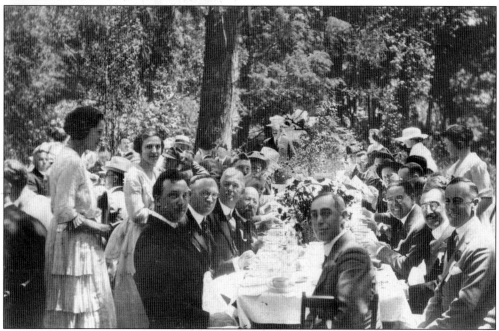

Rotarians enjoy a luncheon on Mills campus, and it appears that students are serving them. Over the years other visitors included Jane Addams, Martin Luther King Jr., Presidents Kennedy and Grant, Booker T. Washington, Samuel Clemens, and Hawaiian queen Liliuokalani. Mills was meant to be called Alderwood (today a dorm's name), but a blueprint showing the title Mills was shown to a newspaper reporter. Later attempts to correct the mistake were futile. (Courtesy Oakland History Room.)

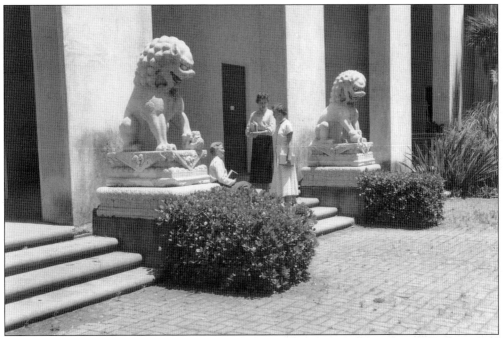

Students (or models) pose in this promotional photo taken in 1952. The Chinese Fu dogs guard the entrance to the art museum. (Courtesy Oakland History Room.)

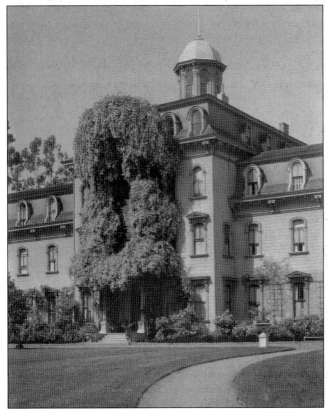

This undated photo shows why Mills Hall was called Rose Porch. Sometimes thick wisteria "turned" the structure purple with its blossoms; other years, white roses covered the porch. The hall survived the 1906 earthquake, but by the early 1970s the upper floors were judged unsafe and were not used. The 1989 earthquake closed it down. It became a grim, disintegrating beauty. By 1994 it was renovated and is now listed on the National Register of Historic Places. (Courtesy Oakland History Room.)

Naturalist Paul Covel reclines on a Leona Heights bridge. Leona is named for the mountain lions that once roamed its hillsides. Native peoples used to paint their bodies with colored clay pigments from the creek bed. At the turn of the century, Leona Heights was the site of the Alma Mine, a quarry nicknamed "The Devil's Punchbowl." It mined iron pyrites (a sulfur source) and had trace gold, silver, and copper in its ore veins, leading to a small gold rush around 1906. The operation had a tramway trestle to carry the ore down the hill, a rock-crushing machine, and lodgings for the miners. Covel wrote, "Hill climbers were thrilled by muffled thunder from underground blasts in the ore tunnels . . . and picturesque miners with lighted candles in their caps." The mine was abandoned in 1915 and Covel took people on tours of the abandoned operation. (Courtesy Oakland History Room.)

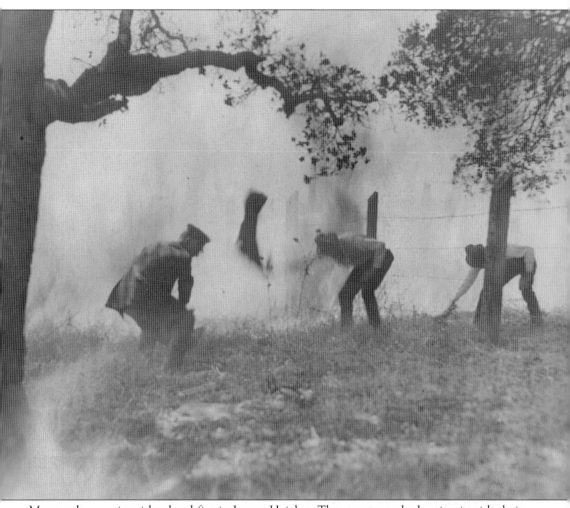

Men work to extinguish a brushfire in Leona Heights. They appear to be beating it with their jackets—the man in the middle is caught in mid-flog. The hills have always been a fire hazard with their heavy vegetation and exposure to winds. This photo was taken in September 1923. (Courtesy Oakland History Room.)

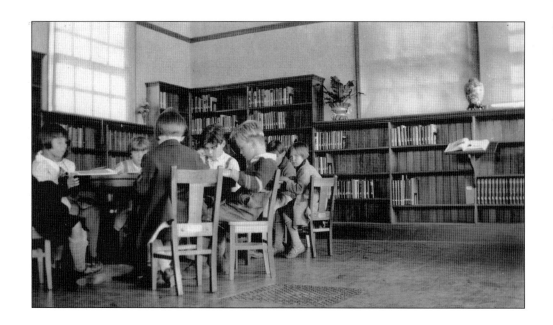

The Gibson library opened in 1925 in a room of the Columbian Park Baptist Mission just five weeks after the suggestion was made. It opened on a Wednesday and by Sunday was running out of books. In 1929 the library moved to a residence at 6915 Sunkist Drive donated by Col. Chauncy Gibson, who also funded the Montclair library. In 1968 service was cut off, much to the dismay of residents. The structure still stands today and neighbors report it is occasionally used by religious groups. These photographs were taken in April 1930. (Courtesy Oakland History Room.)

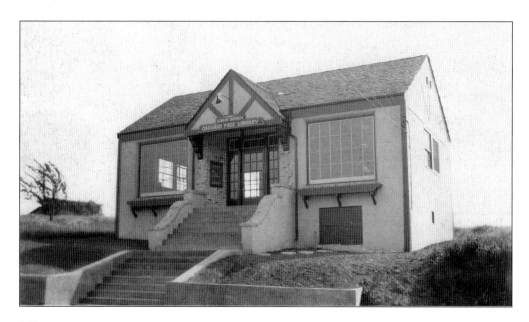

Seven

EASTERN HILLS

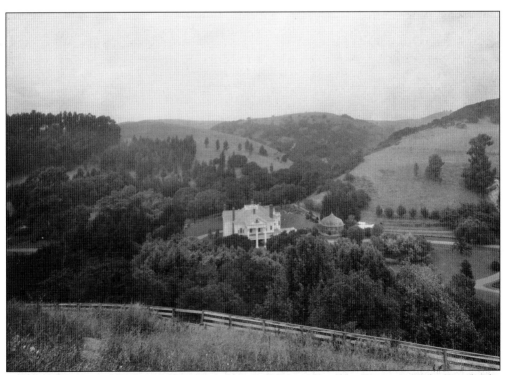

Dunsmuir House was built in 1899 as a wedding gift from Alexander Dunsmuir to his new bride. Unfortunately, he died on their honeymoon and she lived alone in the house for two years until she, too, died. The I.W. Hellman family owned the home next, reversing its bad luck by using it as a summer residence for 14 years. The home is at 2960 Peralta Oaks Court. (Courtesy Oakland History Room.)

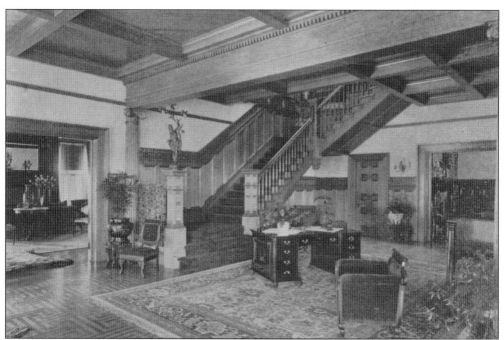

Dunsmuir has paneling throughout its 37 rooms, made of dark woods like mahogany and redwood. Many rooms feature inlaid floors, each with a different pattern. When restoration experts took apart a floor square in the library, they discovered it consisted of 21 small pieces of wood. Dunsmuir was sold to the city in the early 1960s, when it stood in complete disrepair. A volunteer group is responsible for its present, gleaming condition. (Courtesy Oakland History Room.)

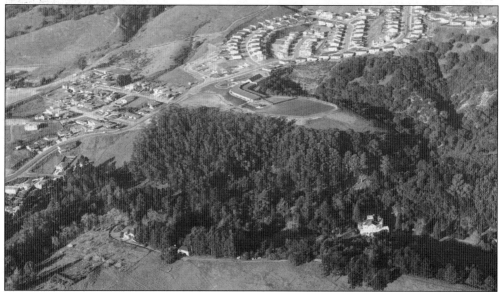

This long view of Dunsmuir shows its once remote status. Today, a nearby freeway, homes, and the East Bay Regional Park District headquarters crowd it somewhat, but the grounds are still sufficiently intact that ducks and deer still consider them home. Dunsmuir was cast as a haunted house in the 1976 horror movie *Burnt Offerings*. (Courtesy Oakland History Room.)

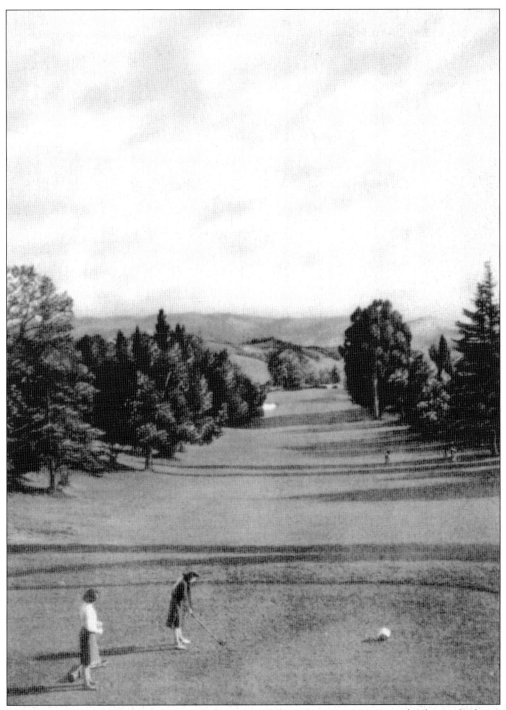

Two women play the links at Sequoyah Country Club in this vintage postcard. They're lucky to be doing so: although the golf course was built in 1913, women were not allowed to play until the 1920s–1930s. A 1926 ad called Sequoyah "a fine golf course, ranking among the best in the U.S." The surrounding Sequoyah Highlands neighborhood was similarly praised: "Many have called it the Beverly Hills of central California." (Courtesy Oakland History Room.)

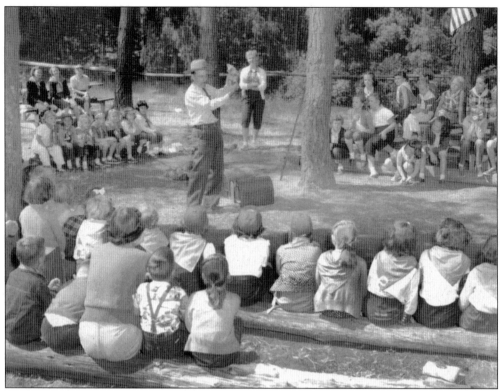

Parks naturalist Paul Covel shares an unidentified animal (above) and skunk (below) with campers at the Blue Bird Day Camp held in Knowland Park, July 1954. (Courtesy Oakland History Room.)

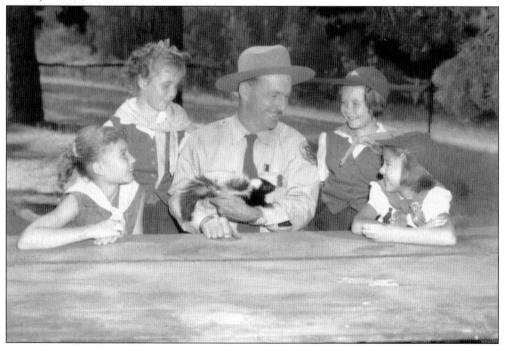

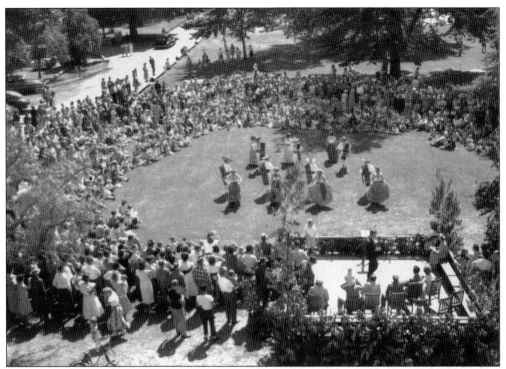

Mexican folk dancers "The Merrymakers" perform in Knowland Park to celebrate its dedication as a state park, May 1950. (Courtesy Oakland History Room.)

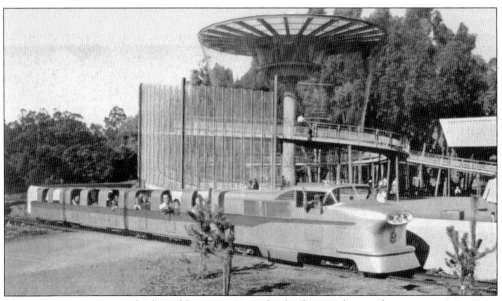

This miniature train with the gibbons' cage in the background provides a great way to get around the Oakland Zoo. The postcard text explains that the train makes a "special journey around the upper canyon rim . . . the highlight of the return trip is a bird's-eye view of the entire zoo area." A roundtrip was 10¢. The Mountain Lion Railway opened in 1941; it was formerly used at the Pan-Pacific Exposition. (Courtesy Oakland History Room.)

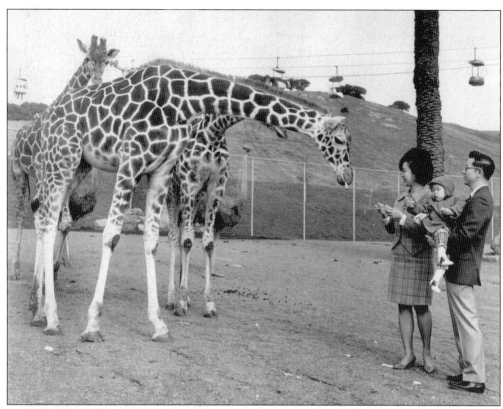

Dr. and Mrs. Wellington R.L. Eng and 19-month-old Wellington Jr. feed bread to the giraffes. A few weeks prior, they had visited the zoo and rode the tram above the new African Veldt exhibition. Curious about the zoo upon disembarking, they began to query a passerby, who by good fortune happened to be zoo director Dr. Raymond Young. By the time the discussion was over, the Engs had donated $1,000 to buy a mate for a gazelle. Several visits later the Engs were planning to purchase a giraffe for the zoo. Baby Wellington would call out the names of giraffes and zebras immediately upon entering Knowland Park. This photograph ran in the *Alameda Times-Star* February 20, 1969. The aerial tram has done more than carry zoo visitors, however. In 1978 Steve Wallenda of the Flying Wallendas walked its wire blindfolded and hooded, only hours after hearing of his uncle's fatal fall in Puerto Rico. For safety, the animals were shuffled out of their enclosures, which were directly beneath the wire, for the stunt. The tram is still operational today. (Courtesy Oakland Zoo.)

This July 1968 photograph shows a zoo employee giving a lion a drink while a pig sniffs around his boots. The zoo has had many homes. In 1922 it was at Lake Merritt (Snow Park); in 1927 in Joaquin Miller Park (at today's Woodminster parking lot); in 1937 in Durant Park (renamed Knowland Park in 1950); and in 1960 just up the hill at the present spot. In 1924, zoo director Sidney Snow brought back a polar bear from an Arctic expedition. While aboard ship, "Wrangel" lost 300 of its 1,800 pounds and died only five years later. Sidney brought back two Eskimos as well, who were amazed at San Francisco's size. Area residents complained of lions roaring at night, and the city council voted in 1943 to close the zoo and have the animals disposed of. Snow argued that during wartime no other zoo was likely to purchase them and so they would have to be shot. Residents rallied and the council resumed its support of the zoo. Today it's run by the East Bay Zoological Society, established by Snow in 1936. (Courtesy Oakland History Room.)

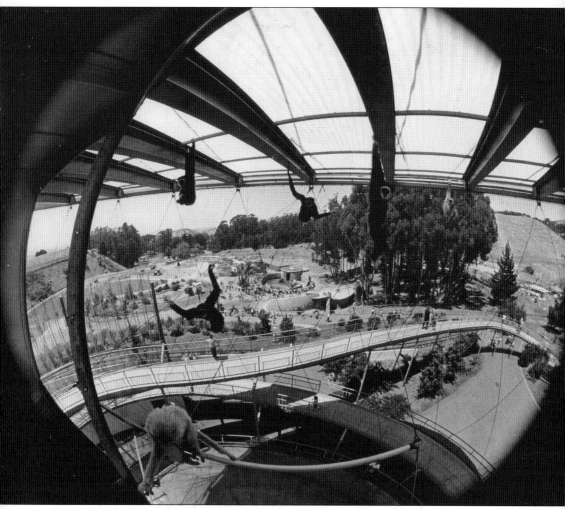

This undated photo gives a gibbon's-eye view of the zoo. This "flying saucer" cage was new in June 1963 and was built for six gibbons. A 300-foot ramp wound around the cage to offer visitors differing perspectives on the animals. It was a stark, vegetation-free environment for the primates, though, who were reduced to swinging on wires rather than leafy vines. The zoo's early inhabitants were treated less humanely than one would hope. Newspaper reports have 1950s zoo director Sidney Snow taking elephant Effie for pleasure rides; he removed the back seat of his car so she would fit, her trunk hanging out the driver's window. Snow also punched an escaped ape on the chin. In 1969 the zoo held a guinea pig race (the animals ran down a ramp lured by lettuce hung from fishing rods), which so terrified the winner that it collapsed and required an injection. The race was accompanied by a costume contest for the animals: clearly not the animal-friendly environment the zoo has evolved into. (Courtesy Oakland History Room.)

Eight

FIRESTORM

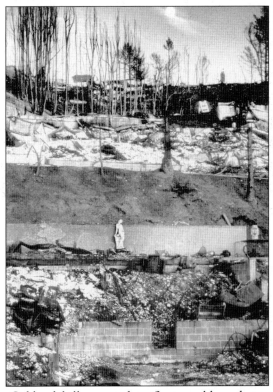

In October 1991 the Oakland hills erupted in flame, a blaze that reached 2,000 degrees Fahrenheit. In only 70 hours the fire consumed 1,600 acres, leaving 25 dead and 5,000 homeless. The fire began near the Caldecott Tunnel and gusted out of control within minutes, jumping the eight-lane Highway 24 and racing with 65 mile-per-hour winds toward Oakland. Here, the moon looks onto a somber scene of destruction. (Courtesy Montclarion/Oakland History Room.)

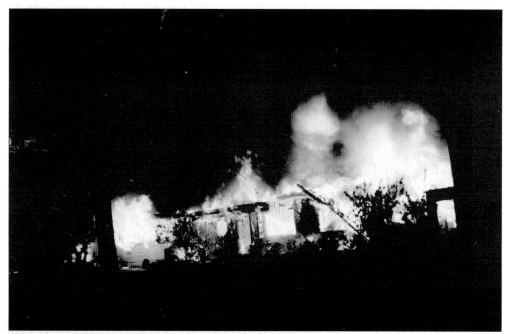

A home on Contra Costa Road goes up in flames. The firestorm torched 3,354 homes and 456 apartments. The overall damage was valued at $1.5 billion, one of the most costly urban wildfires in U.S. history. (Courtesy Hans Raub/ Oakland History Room.)

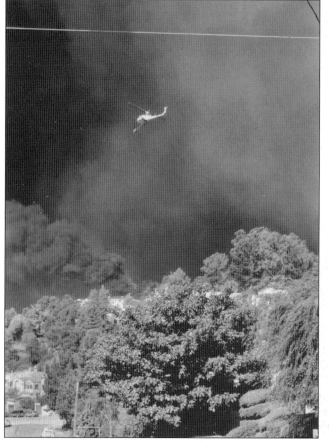

A helicopter carrying water from Lake Temescal flies through the smoke. This photo was taken on Proctor Avenue looking toward Broadway Terrace. The fire burned power lines, affecting the ability of water plants to supply firemen. Ten reservoirs were entirely drained by firefighting efforts. (Courtesy Lance Nishihara/ Oakland History Room.)

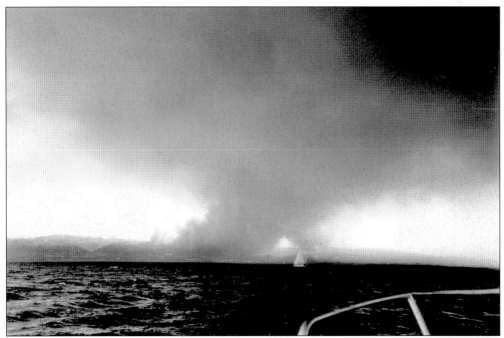

These rare views from the water were taken by an Encinal Yacht Club member. Ironically, while winds buffeted the hills and spread the fire, the bay was sufficiently windless that a two-day yacht race was canceled. In the bottom photo, sparks of burning material can be seen in the water. When Doralyn Poirier returned home to Alameda, a 14-inch four-by-four timber sat in her driveway; it disintegrated on contact. (Courtesy Doralyn Poirier/Oakland History Room.)

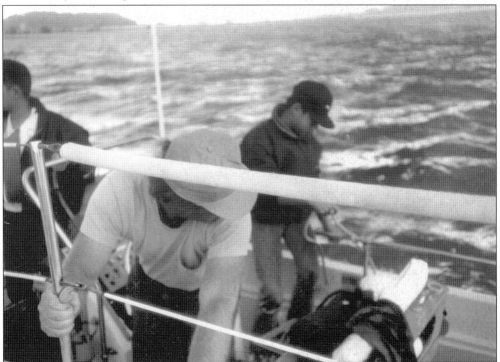

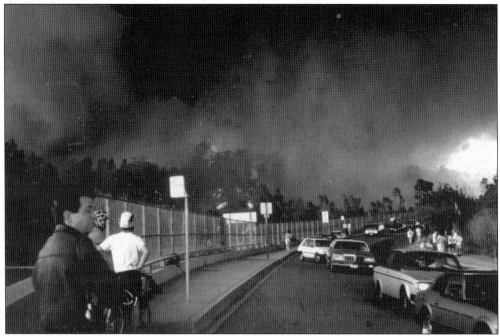

Dana Heidrick and boyfriend Lance Nishihara drove a new sports car into the hills to see what was going on. They took a few pictures, then realized it was foolish to linger. Heidrick, who lives on Lawton, remembers leaving her cat in its carrier all day Sunday in the event she needed to evacuate (she didn't). Twice she went into her backyard to find total strangers spraying her roof with water. (Courtesy Lance Nishihara/Oakland History Room.)

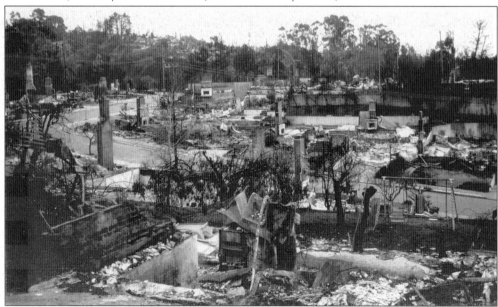

Welcome to the neighborhood. The bitter aftermath of the fire is evident. The thin, winding roads in the hills made access difficult for firefighters. Eleven victims died in a traffic jam at one intersection (Charing Cross Road), and eight others died on similarly narrow streets. (Courtesy Shirley Warwick/Oakland History Room.)

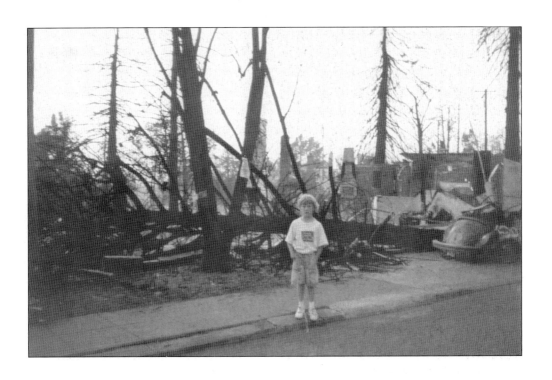

Young and old try to cope with the devastating loss. (Courtesy Oakland History Room.)

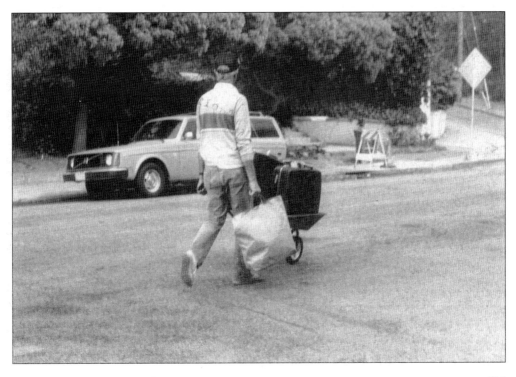

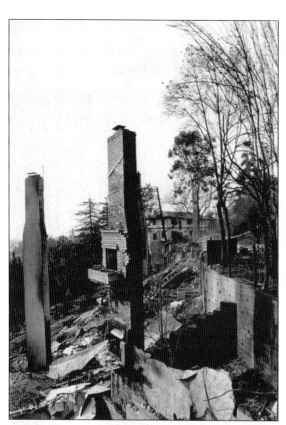

A haunting sight amidst the ruins are the fireplaces strangely perched in mid-air. This is upper Broadway Terrace. (Courtesy Mark Nollinger/ Montclarion/Oakland History Room.)

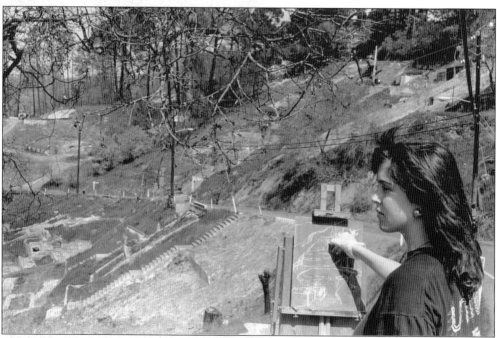

Staircases led nowhere in the twisted dreamworld of the burned hills. (Courtesy Oakland History Room.)

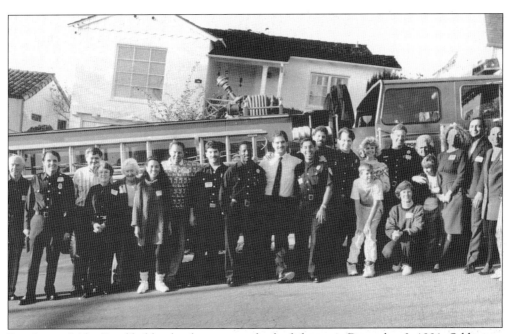

Residents of Alta Road held a thank-you party for firefighters on December 3, 1991. Odds were against the firefighters: around noontime on October 20, a home was ignited every 11 seconds. (Courtesy Montclarion/Oakland History Room.)

A community memorial is ironically placed at the foot of a eucalyptus. Many blamed the eucalyptus, a highly-flammable Australian tree, for the rapid spread of the fire. The non-native trees were planted by loggers after the decimation of the redwoods in the 1800s. Also culpable was residents' lack of defensible space between houses and vegetation, still a concern after the rebuilding of the hills. Unfortunately, memories are short. (Courtesy Carolyn Younger/Montclarion/Oakland History Room.)

After all of the tragedies, people raise their chins and begin again. Here, eight-year-old Kate Scott rides on Alvarado Road. Her mother says, "The fire teaches you how you live when the sky is falling." The family lost grandmother Frances Scott to the fire, as Kate's sister Ginny tried frantically to get 911 operators to act. When neighbors returned post-fire, Kate went door-to-door introducing herself, ensuring that everyone knew each other, a potentially life-saving measure in a similar situation. (Courtesy Teresa Ferguson-Scott.)

Children do handstands even in the midst of a forlorn landscape. Life has to pick up and begin again, and these schoolchildren show how it's done. Oakland residents are resilient and know that the fire can't destroy the spirit of the hills. (Courtesy Montclarion/Oakland History Room.)